# 韓國繪師的
# 角色繪製
# 重點攻略

POINT CHARACTER DRAWING

## TACO

**vol.2**

## Prologue

　　大家好，我是以TACO為筆名，進行創作活動的崔元喜。

　　《韓國繪師的角色繪製重點攻略》這本書，是我擔任基礎角色繪圖講師的工作時，以一天一張、一週五張的進度為開端，持續繪製學生們感到好奇或是適合繪者們閱讀的內容，總共匯集了兩年多來的繪畫作品，才得以集結成冊的。或許因為本書的製作與出版亦是遵守了我與自己的約定，因此雖然過了一段時間，心中的感觸卻歷久彌新。

　　本次在企劃時，我將本書分為上、下二冊，使書籍便於攜帶，並在書中區分出章節段落，提升學習效率。

　　雖然在練習繪畫技巧時，照著原書描圖、參考書籍作畫也是很好的方法，但我認為書中這些理論，若能輕便地隨身攜帶、隨時閱讀，對於透過閱讀、熟練繪畫技巧的意象訓練（Image Training）也很有幫助。

我深刻期許，各位在繪畫時不要只透過單一情報，而是透過無數資料、累積知識來豐富作畫內涵。在多不勝數的資訊海洋之中，亦期盼本書能對讀者們有所助益。

　　此外，我想向我的父母致謝，感謝他們在艱辛的環境中辛苦拉拔兩個兒子長大成人，僅將感激之情留於書中。我也想對親愛的妻子說聲感謝，謝謝妳總是在我身邊給予無盡的愛和幫助。

　　每日不懈工作，當然也會有疲憊的時刻，但我始終感激自己能夠從事心中熱愛的工作，也會持續不綴地創作，腳踏實地地為有志於繪畫的朋友們努力，希望多多少少能成為一份助力。

　　我也要感謝LEZHIN出版社，直到書籍出版為止，始終尊重作者每一個細微的意見，也為讀者們把關、堅持出版優良的書籍。

　　謝謝大家。

# CONTENTS

## Part 3

# 臉部 face 9

# Part 4

# Part 5

# 韓國繪師的
# 角色繪製
# 重點攻略

POINT CHARACTER DRAWING

## TACO

**vol.2**

臉部＋腿部

# 韓國繪師的角色繪製重點攻略

# Part 3 臉部

face

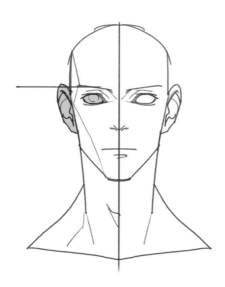

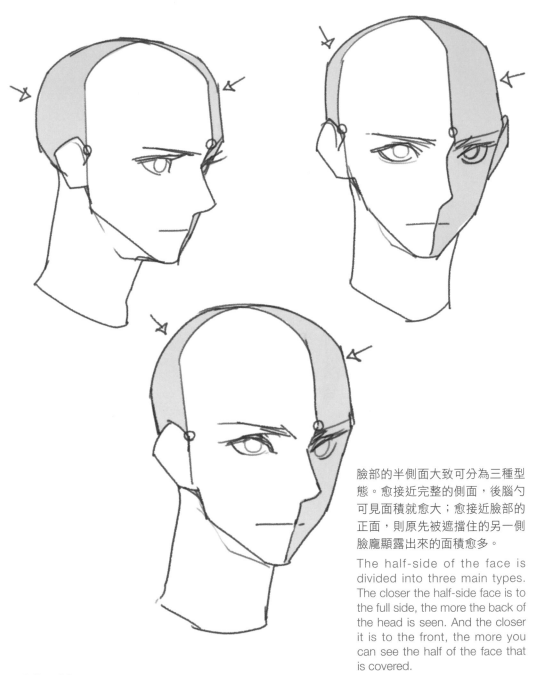

臉部的半側面大致可分為三種型態。愈接近完整的側面，後腦勺可見面積就愈大；愈接近臉部的正面，則原先被遮擋住的另一側臉龐顯露出來的面積愈多。

The half-side of the face is divided into three main types. The closer the half-side face is to the full side, the more the back of the head is seen. And the closer it is to the front, the more you can see the half of the face that is covered.

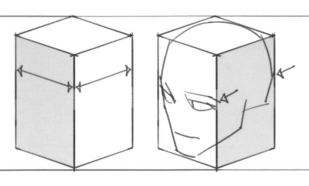

以基本的半側面角度來說，帶有眼睛、鼻子、嘴巴的臉部正面，與帶有耳朵的側面大致同寬，眉毛尾端和後腦勺則應分別接觸到面部的轉折處。

For the basic face from a three quarter view angle, the front of the face (where the eyes, nose, and mouth are located) should be equal in length to the side of the face (where the ear is located). The side of the face starts at the tip of the eyebrow and ends at the back on the head from this angle.

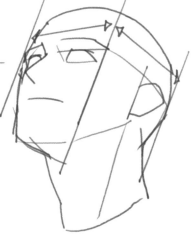

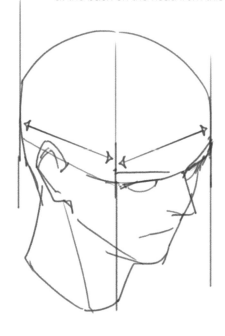

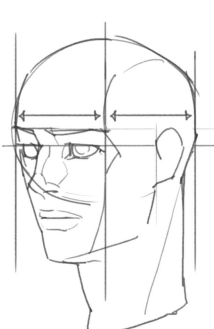

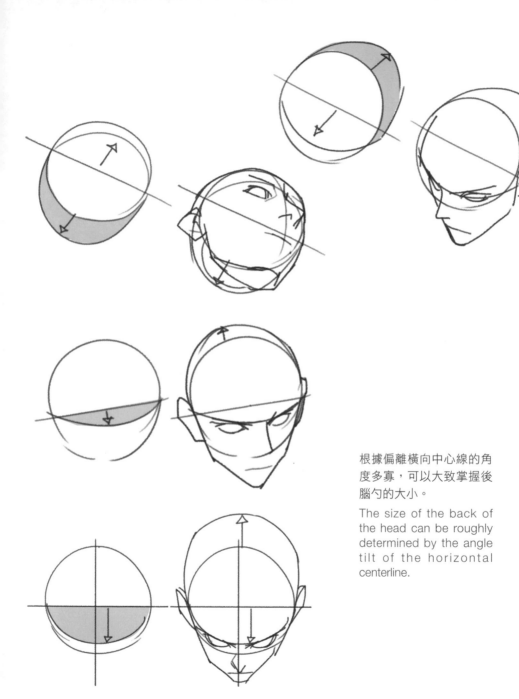

根據偏離橫向中心線的角度多寡，可以大致掌握後腦勺的大小。

The size of the back of the head can be roughly determined by the angle tilt of the horizontal centerline.

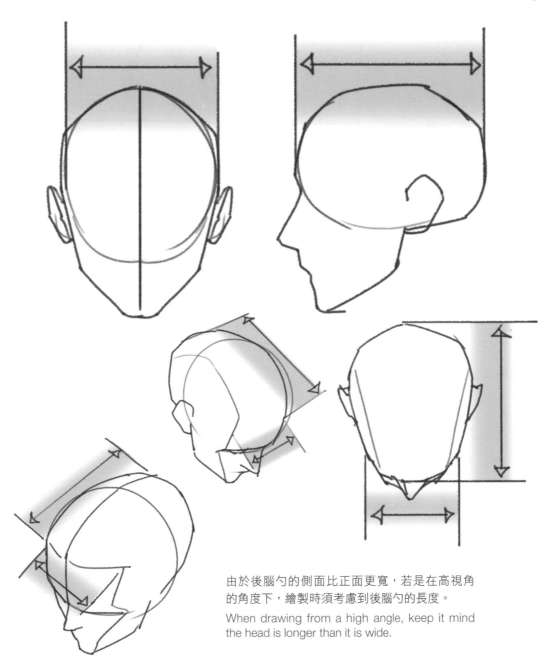

由於後腦勺的側面比正面更寬，若是在高視角的角度下，繪製時須考慮到後腦勺的長度。

When drawing from a high angle, keep it mind the head is longer than it is wide.

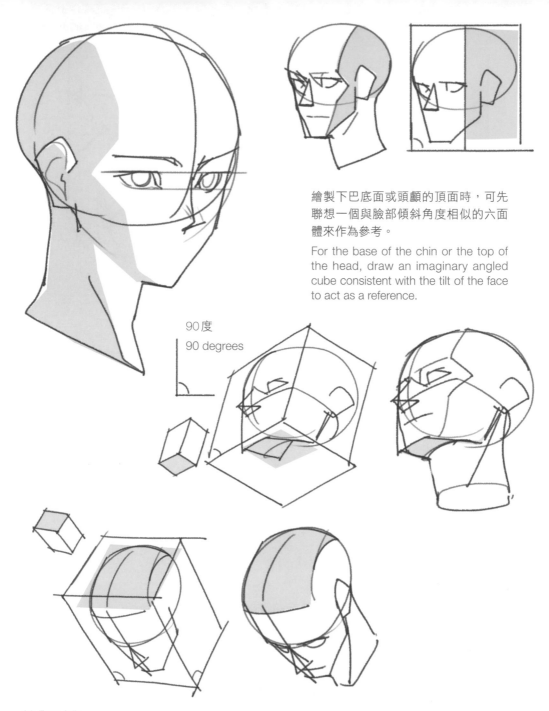

繪製下巴底面或頭顱的頂面時，可先聯想一個與臉部傾斜角度相似的六面體來作為參考。

For the base of the chin or the top of the head, draw an imaginary angled cube consistent with the tilt of the face to act as a reference.

90度
90 degrees

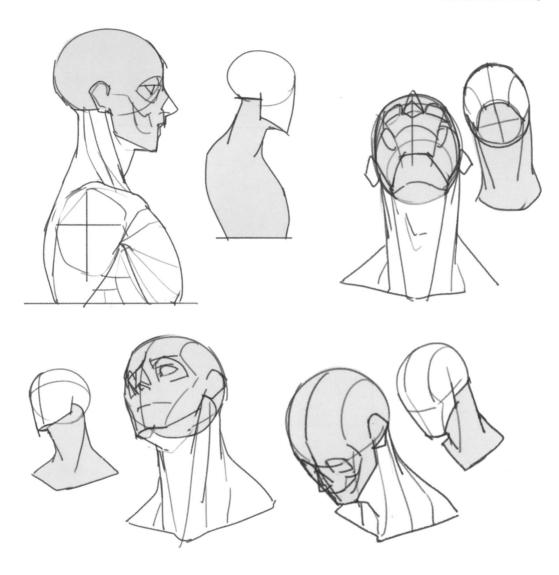

若將臉部視為一個單純的骷體型態再連接頸部，就能輕鬆地畫出富立體感的
各種角度。（當然，即便視為骷體型態來繪製也需要充分的練習。）

Picturing the face in the form of a simple skull and then attaching the neck
makes it easier to draw various angles of the face in three-dimensions.
(Recognizing faces in the form of skulls, of course, requires practice)

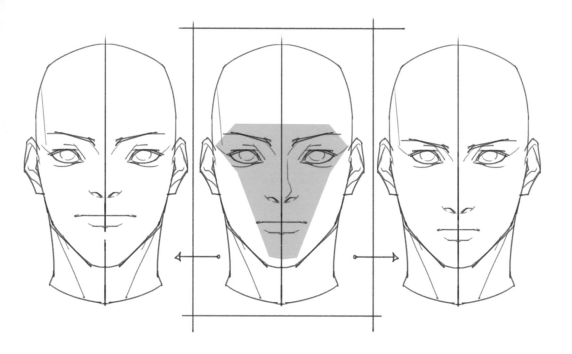

五官的位置相當重要。因為就基本型態來觀察，眉間較寬或較窄、鼻梁較長或較短、嘴型較大或較小，及眼睛的高度都會產生細微差異，形成不同的印象。

The position of the ears, eyes, mouth, and nose is very important. This is because the impression changes if there is a difference in the basic shape of the features, such as widening or narrowing between the eyebrows, shortening or lengthening the nose, the mouth getting bigger or smaller, or the height changing slightly.

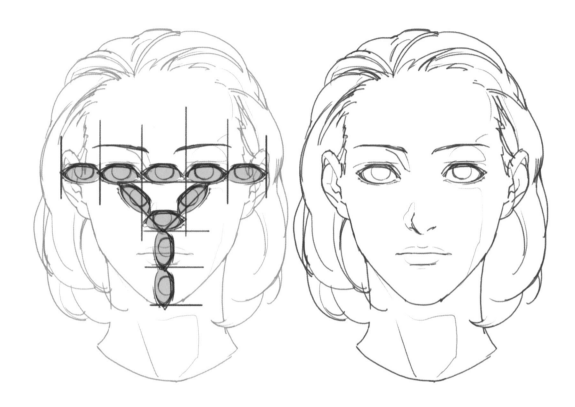

單靠一隻眼睛的長度，就能大致決定臉部五官的位置。

The location of the facial features (ears, eyes, mouth and nose) can be determined with just the length of one eye.

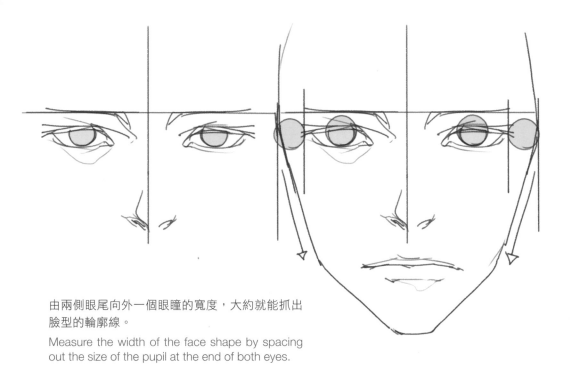

由兩側眼尾向外一個眼瞳的寬度，大約就能抓出臉型的輪廓線。

Measure the width of the face shape by spacing out the size of the pupil at the end of both eyes.

眼尾的寬度愈窄，就愈具漫畫風格。

The narrower the width of the ends of the eyes, the more it looks like a cartoon.

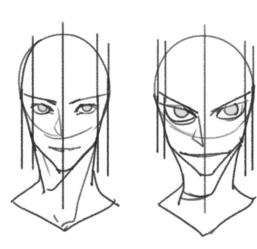

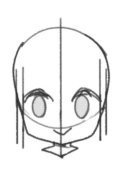

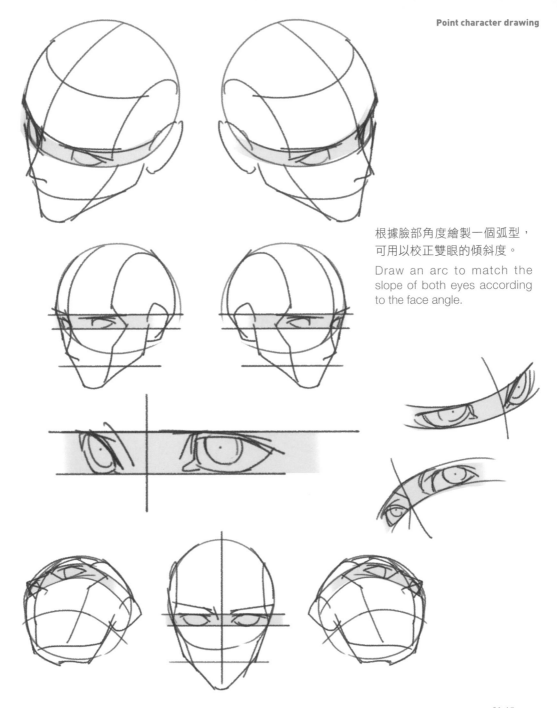

根據臉部角度繪製一個弧型，
可用以校正雙眼的傾斜度。

Draw an arc to match the
slope of both eyes according
to the face angle.

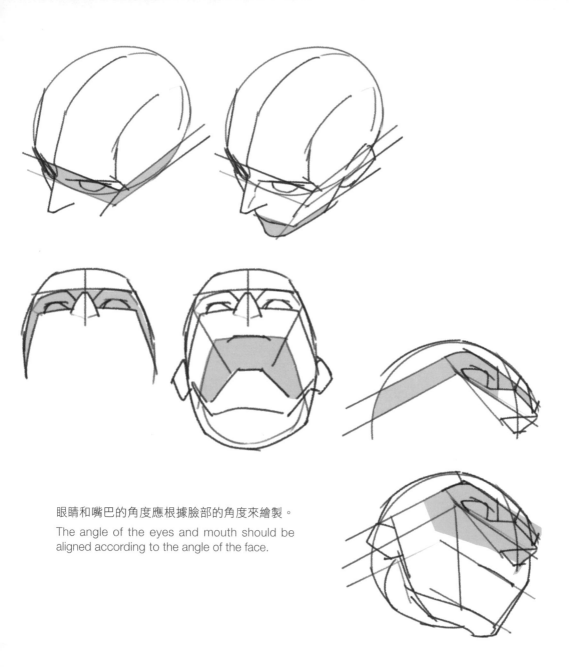

眼睛和嘴巴的角度應根據臉部的角度來繪製。

The angle of the eyes and mouth should be aligned according to the angle of the face.

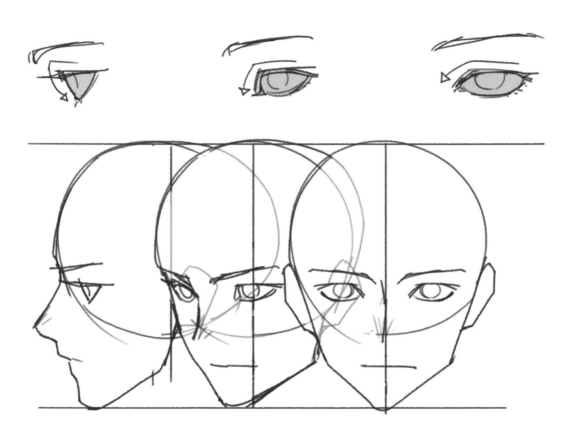

在不同的臉部角度下，眼睛起始點的傾斜度也會因
畫風而有所不同。

Depending on the drawing style, the slope of the
eye start point at various facial angles varies.

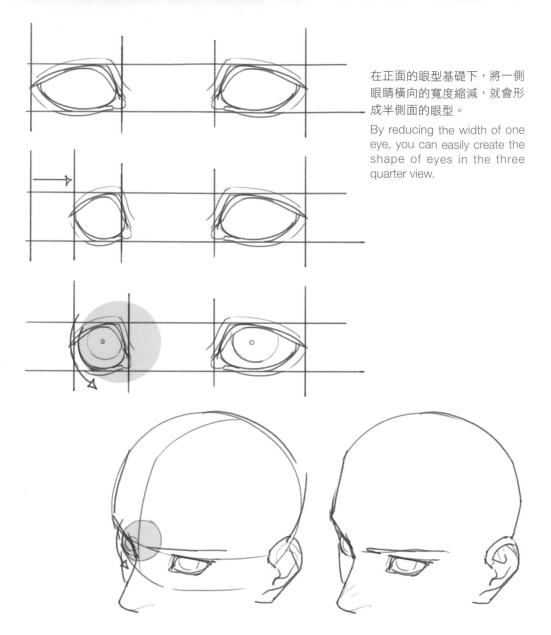

在正面的眼型基礎下，將一側眼睛橫向的寬度縮減，就會形成半側面的眼型。

By reducing the width of one eye, you can easily create the shape of eyes in the three quarter view.

繪製眼球外表的曲線時，須考慮到眼球的型態（圓形球體）。

Consistent with the circle of the eyeball, make the outer part of the eye curved.

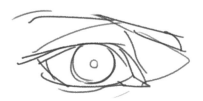

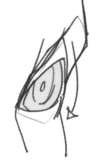

若是在半側面角度下，眼睛貼近臉部輪廓的情況，須依據眼球的型態畫出曲線狀的臉部外輪廓。

For the half-sided angle at which one eye contacts the face line, the silhouette of the face curve is drawn following the shape of the pupil.

如果是漫畫風格，線條可適當省略，不需相連。

If you are drawing in a cartoon style, the face line can be disregarded.

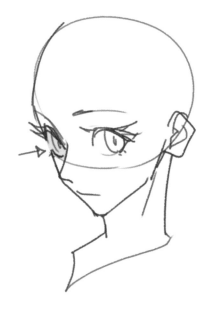

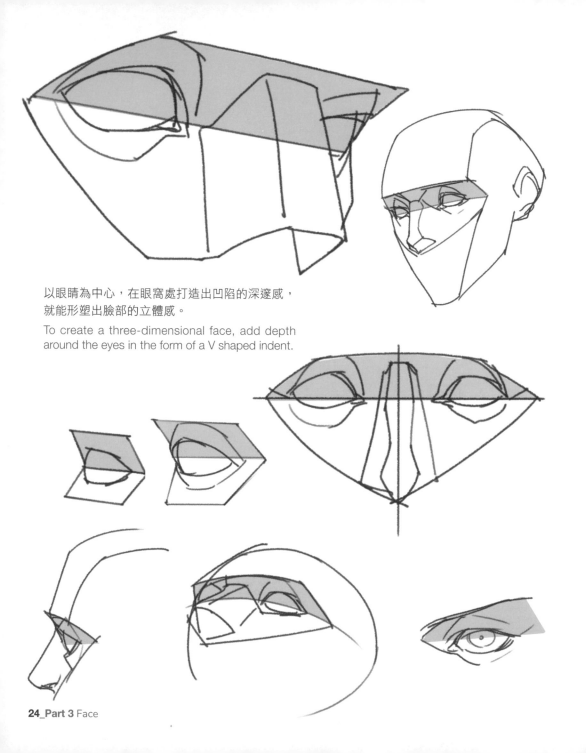

以眼睛為中心，在眼窩處打造出凹陷的深邃感，
就能形塑出臉部的立體感。

To create a three-dimensional face, add depth
around the eyes in the form of a V shaped indent.

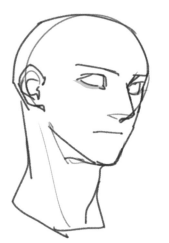
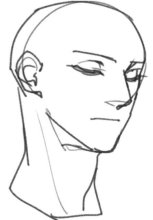
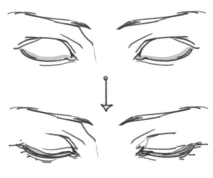

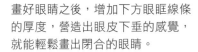

畫好眼睛之後，增加下方眼眶線條
的厚度，營造出眼皮下垂的感覺，
就能輕鬆畫出閉合的眼睛。

After drawing the eyes, you
can easily draw closed eyes by
thickening the lower line of the
eyelids.

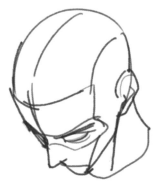
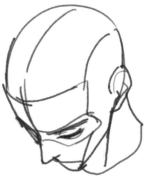

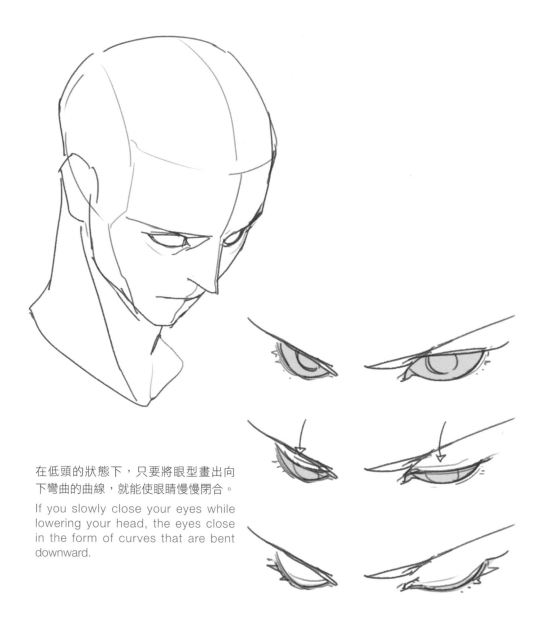

在低頭的狀態下，只要將眼型畫出向下彎曲的曲線，就能使眼睛慢慢閉合。

If you slowly close your eyes while lowering your head, the eyes close in the form of curves that are bent downward.

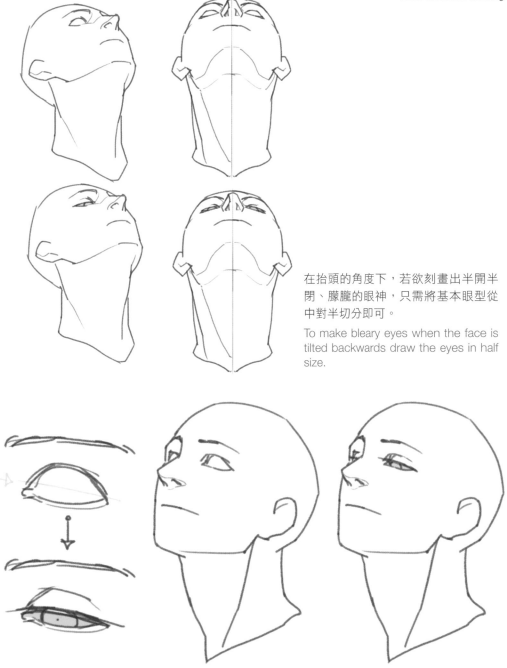

在抬頭的角度下，若欲刻畫出半開半閉、朦朧的眼神，只需將基本眼型從中對半切分即可。

To make bleary eyes when the face is tilted backwards draw the eyes in half size.

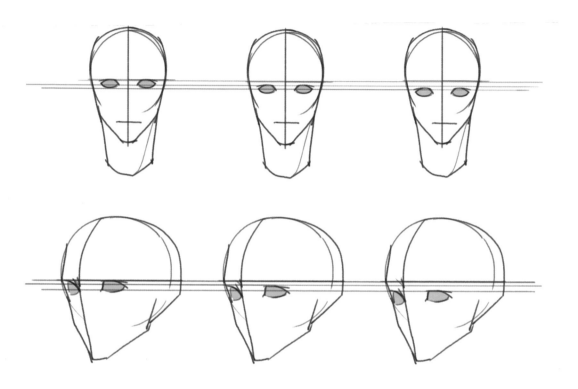

僅從臉部上眼睛位置的高低，就能形成不同的角色
年齡和形象。

The height of the eyes on the face alone changes the
age range and impression of the character.

若要打造表情生動的眼睛，只要統一眉毛
和眼睛的走向即可。

To create dynamic facial expressions, it
helps to match the flow of the eyebrows
with the eye shapes.

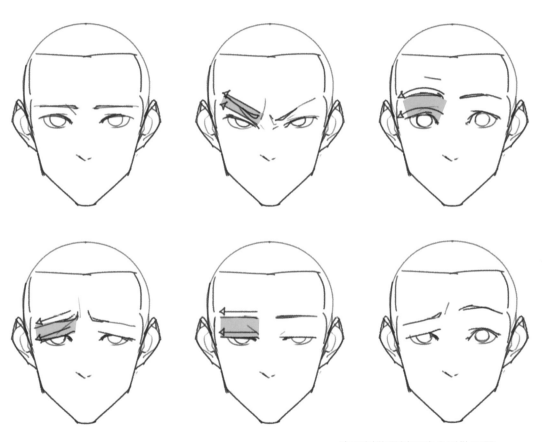

也可以將兩側眼睛分別做不同
的運用。

This works with one or both
eyes.

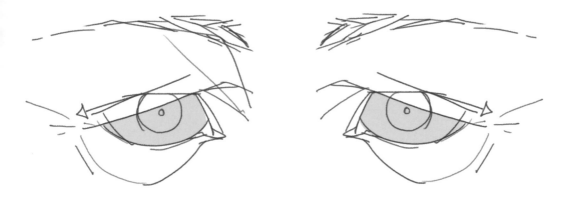

光是眼睛上半部的形狀就可以打造出眼睛多樣化的表現。

The line flow of the upper eye alone enables various eye expressions.

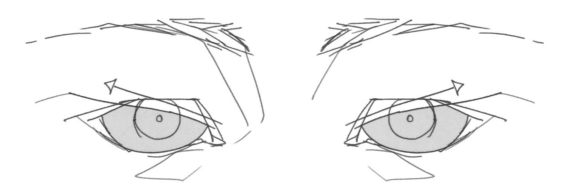

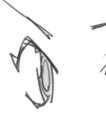
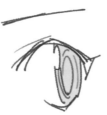
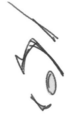
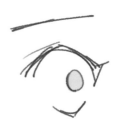

透過瞳孔大小的變化，能傳達出角色的情緒。

Just by changing the size of the pupils,
the emotions of the character are conveyed.

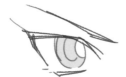
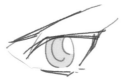
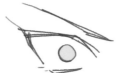
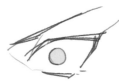

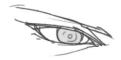
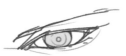
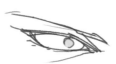

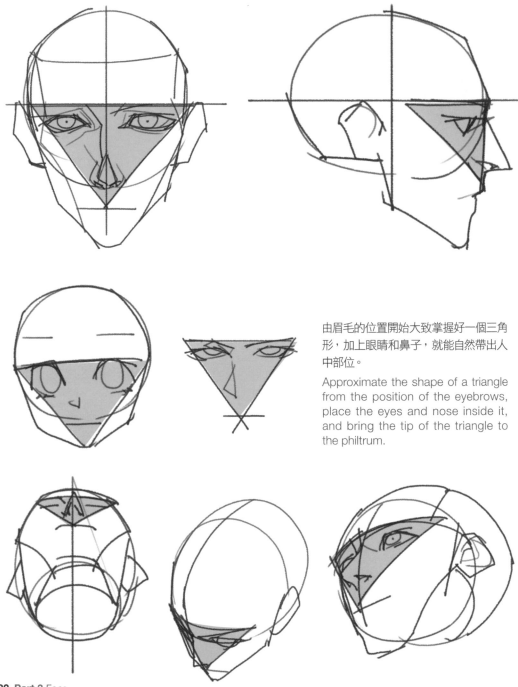

由眉毛的位置開始大致掌握好一個三角形，加上眼睛和鼻子，就能自然帶出人中部位。

Approximate the shape of a triangle from the position of the eyebrows, place the eyes and nose inside it, and bring the tip of the triangle to the philtrum.

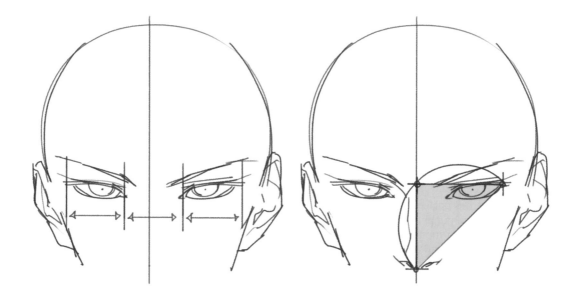

由眉間的中心至眼尾的長度，就能掌握好鼻梁的位置。
當然，按照畫風不同，測量方式也有所不同。

The position of the nose can be determined by the length
from the midpoint between the two eyebrows to the
tail of the eye. Of course, this calculation method varies
depending on the drawing style.

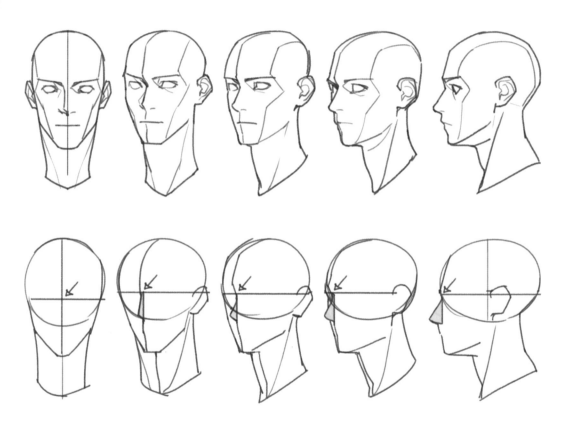

隨著臉部轉動，臉部的中心線也會改變，此時，鼻子會成為臉部的中心。若中心線的位置改變，鼻梁的高度也會隨著角度有所不同。

The centerline of the face changes as the face rotates. At this time, the nose plays a central role. The nose also changes its centerline position and its height varies depending on the face angle.

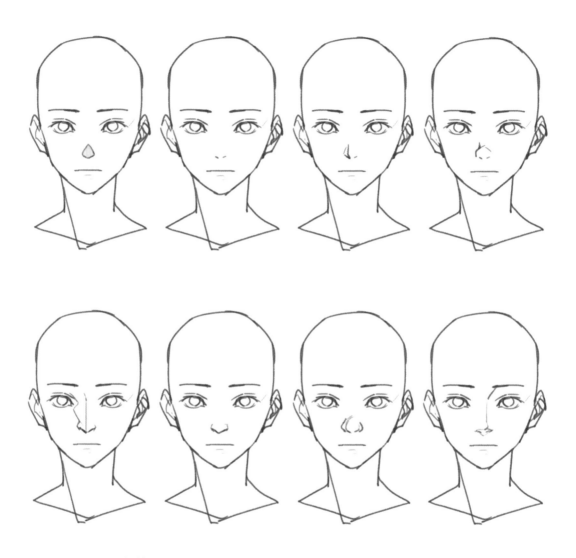

根據鼻梁線條表現不同，鼻子可能顯得較高或較低，也有可能
看起來較高聳或較寬扁。

Depending on the shape of the nose line, the nose may appear
high or low, and may look lifted or wide.

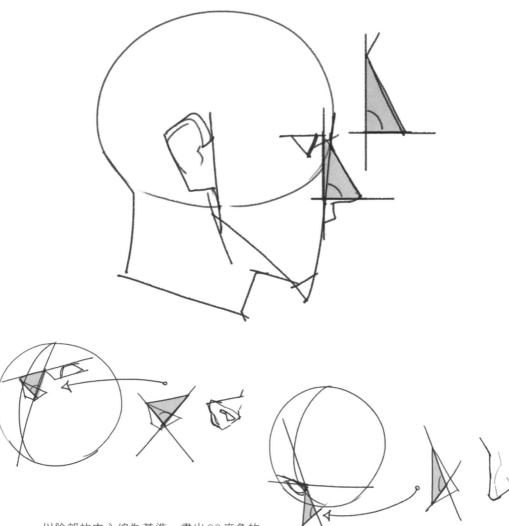

以臉部的中心線為基準，畫出90度角的垂直線與水平線，就能抓出各種角度下的鼻子型態。

The vertical and horizontal lines can be made 90 degrees from the centerline of the face to form a different angle of the nose.

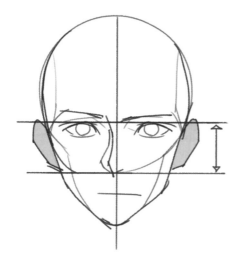

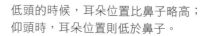
低頭的時候，耳朵位置比鼻子略高；
仰頭時，耳朵位置則低於鼻子。

When the head is lowered, the ears are placed above the nose, and when the head is raised, the ears are below the nose.

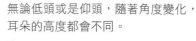
無論低頭或是仰頭，隨著角度變化，耳朵的高度都會不同。

There is a difference in the height of the ear position depending on the angle at which the head is lowered or raised.

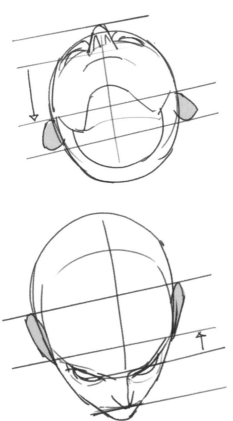

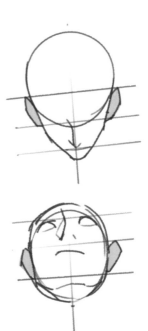

耳朵的高度位於眉毛和鼻尖之間，長度與鼻子相近。只要找出臉部正面彎折至側面的角度，就能輕鬆找到耳朵的位置。

The ears are positioned between the eyebrows and the tip of the nose, and their length is similar to that of the nose. It is easy to find the position of the ears by just matching the angles of the front and sides of the face.

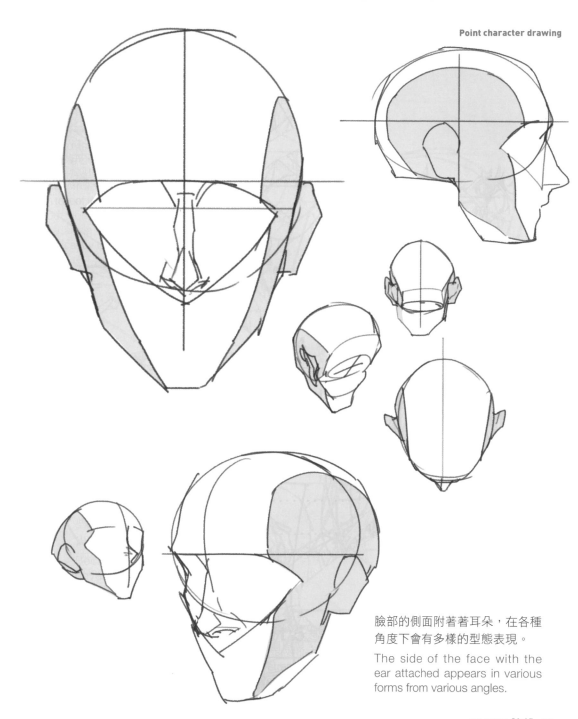

臉部的側面附著著耳朵，在各種
角度下會有多樣的型態表現。

The side of the face with the
ear attached appears in various
forms from various angles.

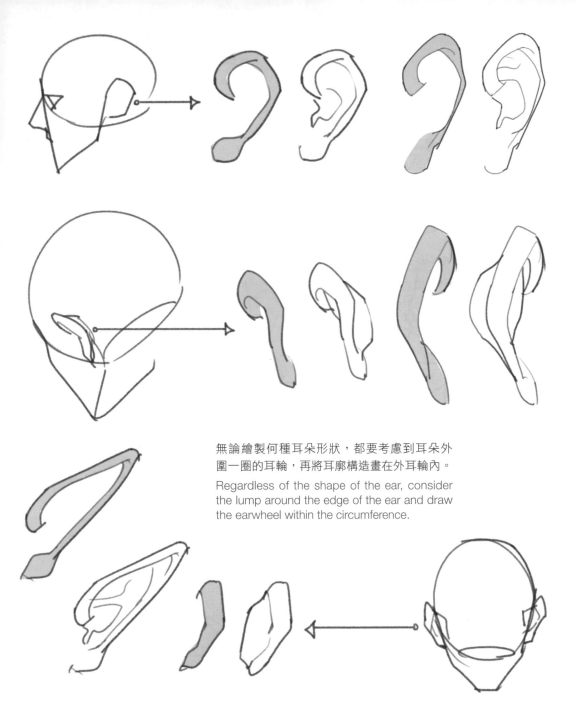

無論繪製何種耳朵形狀，都要考慮到耳朵外圍一圈的耳輪，再將耳廓構造畫在外耳輪內。

Regardless of the shape of the ear, consider the lump around the edge of the ear and draw the earwheel within the circumference.

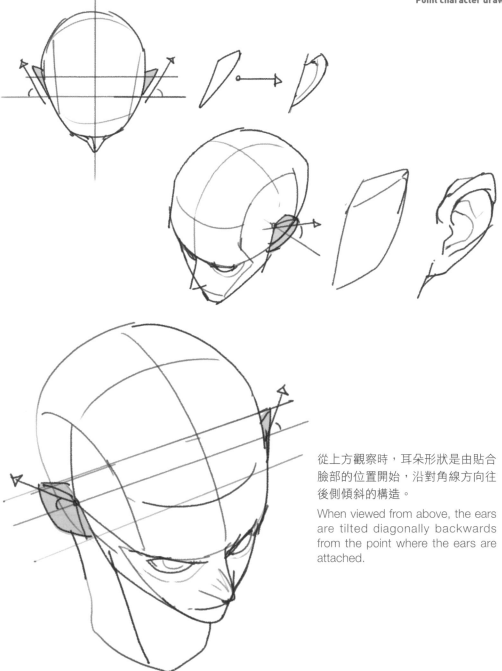

從上方觀察時，耳朵形狀是由貼合臉部的位置開始，沿對角線方向往後側傾斜的構造。

When viewed from above, the ears are tilted diagonally backwards from the point where the ears are attached.

根據臉部側面的角度，就能
輕鬆掌握耳朵的型態和角度。

The shape and angle of the
ear can be drawn matching
the angle of the side of the
face.

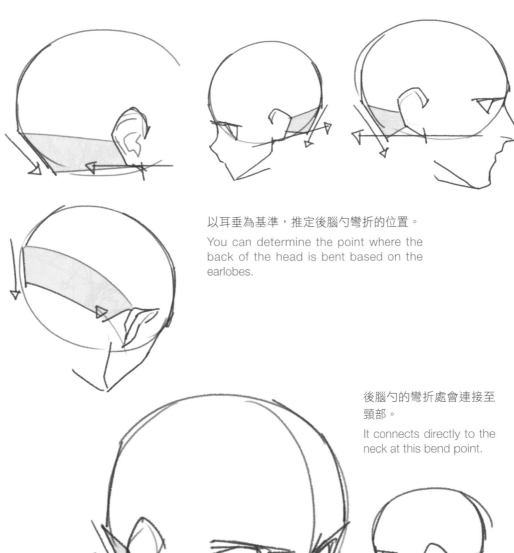

以耳垂為基準，推定後腦勺彎折的位置。

You can determine the point where the back of the head is bent based on the earlobes.

後腦勺的彎折處會連接至頸部。

It connects directly to the neck at this bend point.

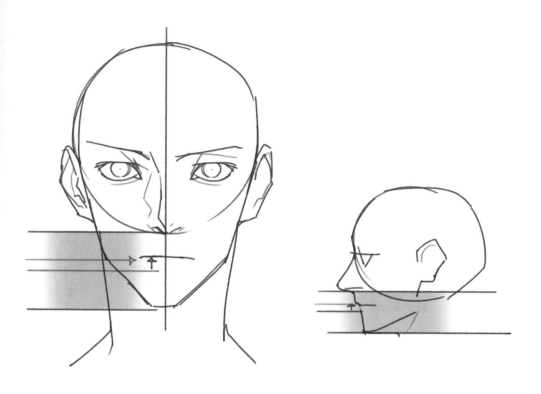

若將下巴長度一分為二，嘴巴會略高於一半的位置。

The mouth is slightly above the midpoint of the jaw length.

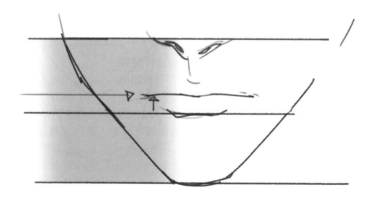

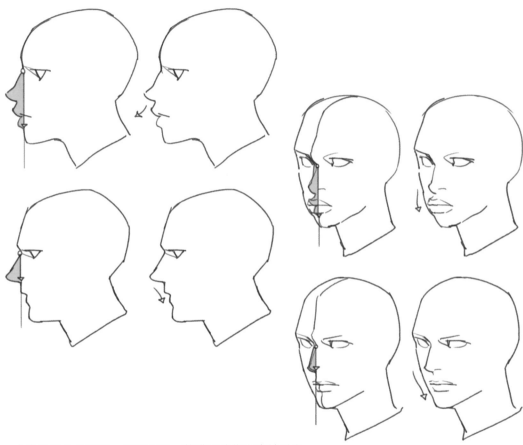

由鼻梁起始處繪製一條垂直線，若嘴唇線條突出於垂直線外，就會顯得嘴唇向外突出，反之則會有嘴唇向內收縮的感覺。

If the lip line comes up to the vertical line at the point where the nose bridge begins, the mouth appears to protrude outward. Otherwise the mouth appears to go inward.

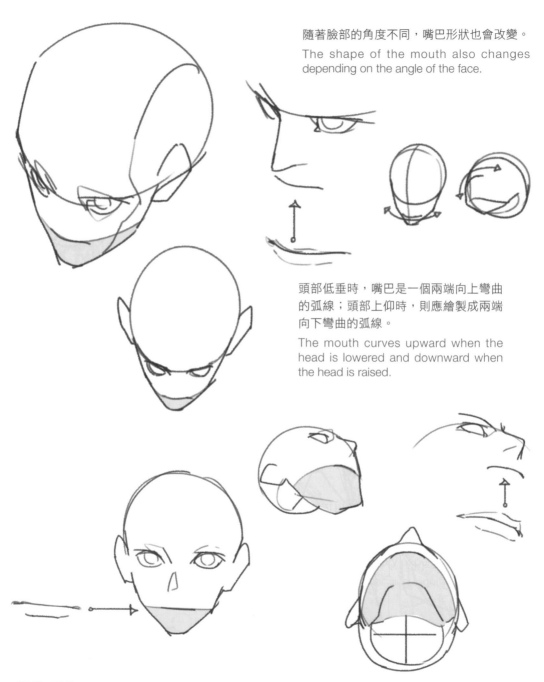

隨著臉部的角度不同，嘴巴形狀也會改變。

The shape of the mouth also changes depending on the angle of the face.

頭部低垂時，嘴巴是一個兩端向上彎曲的弧線；頭部上仰時，則應繪製成兩端向下彎曲的弧線。

The mouth curves upward when the head is lowered and downward when the head is raised.

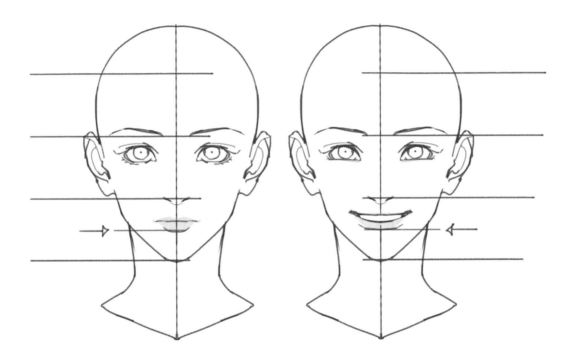

在微笑的情況下，下唇的位置保持不變，上唇向上提，顯露出上排牙齒。

When laughing, the position of the lower lip remains unchanged, but the upper teeth are visible as the upper lip rises.

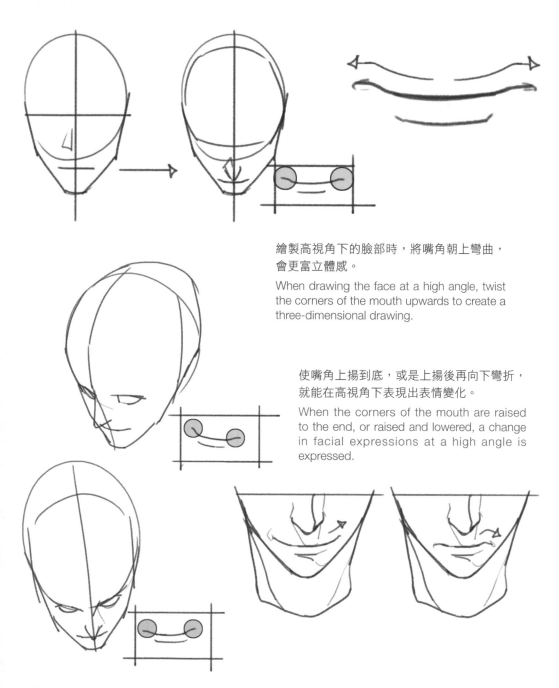

繪製高視角下的臉部時，將嘴角朝上彎曲，
會更富立體感。

When drawing the face at a high angle, twist
the corners of the mouth upwards to create a
three-dimensional drawing.

使嘴角上揚到底，或是上揚後再向下彎折，
就能在高視角下表現出表情變化。

When the corners of the mouth are raised
to the end, or raised and lowered, a change
in facial expressions at a high angle is
expressed.

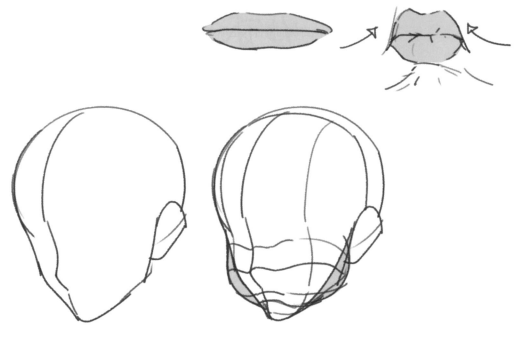

若欲表現出兩頰鼓起的狀態，在基本臉型上強調出臉頰部分的輪廓，並將嘴形縮短聚攏即可。

To draw a face with air in both cheeks, shorten the mouth shape and change only the silhouette of the cheeks.

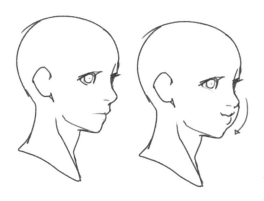
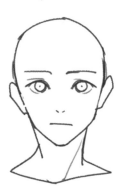
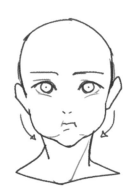

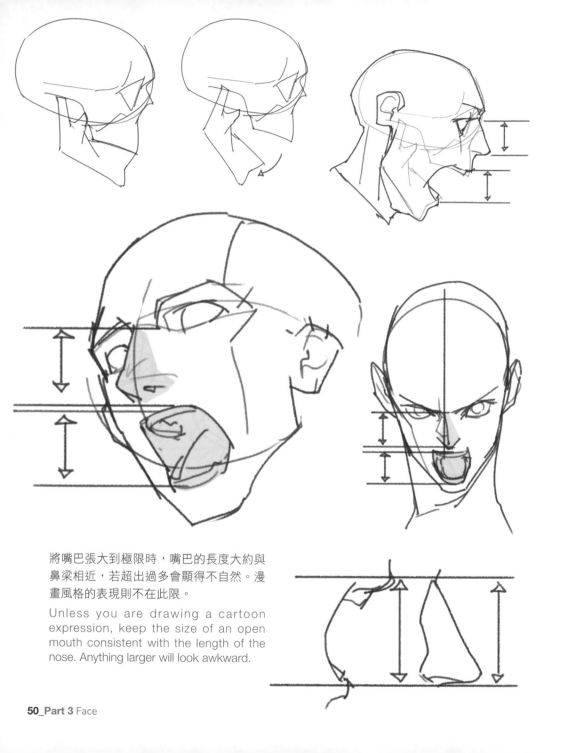

將嘴巴張大到極限時，嘴巴的長度大約與鼻梁相近，若超出過多會顯得不自然。漫畫風格的表現則不在此限。

Unless you are drawing a cartoon expression, keep the size of an open mouth consistent with the length of the nose. Anything larger will look awkward.

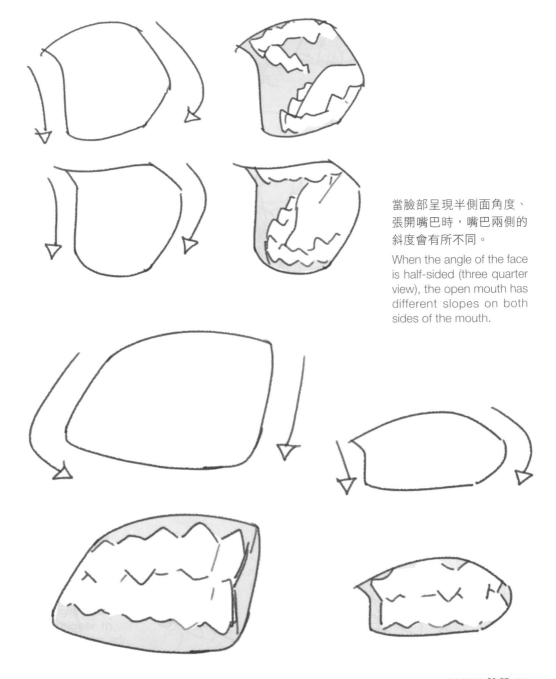

當臉部呈現半側面角度、張開嘴巴時，嘴巴兩側的斜度會有所不同。

When the angle of the face is half-sided (three quarter view), the open mouth has different slopes on both sides of the mouth.

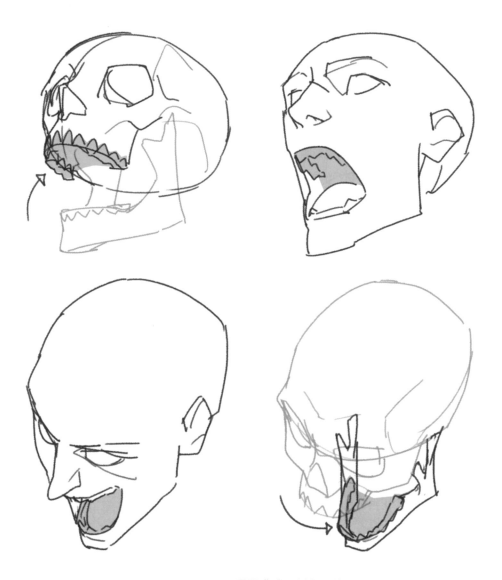

張開嘴時，低角度情況下主要能看見上排牙齒；
高角度情況下則重點為下排牙齒。

Regarding an open mouth, the upper teeth are
mainly seen from a low angle, and the lower teeth
are mainly seen from a high angle.

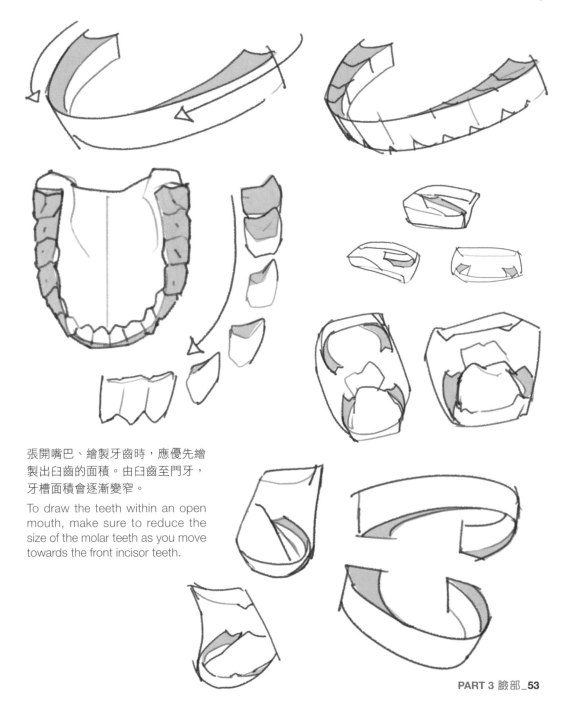

張開嘴巴、繪製牙齒時，應優先繪製出臼齒的面積。由臼齒至門牙，牙槽面積會逐漸變窄。

To draw the teeth within an open mouth, make sure to reduce the size of the molar teeth as you move towards the front incisor teeth.

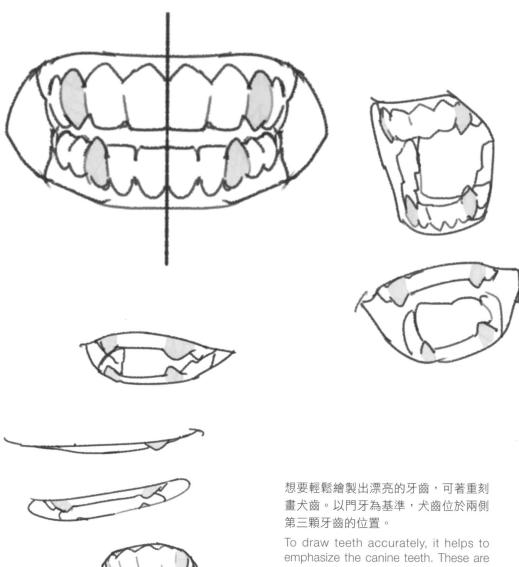

想要輕鬆繪製出漂亮的牙齒，可著重刻畫犬齒。以門牙為基準，犬齒位於兩側第三顆牙齒的位置。

To draw teeth accurately, it helps to emphasize the canine teeth. These are positioned as the third teeth from the center.

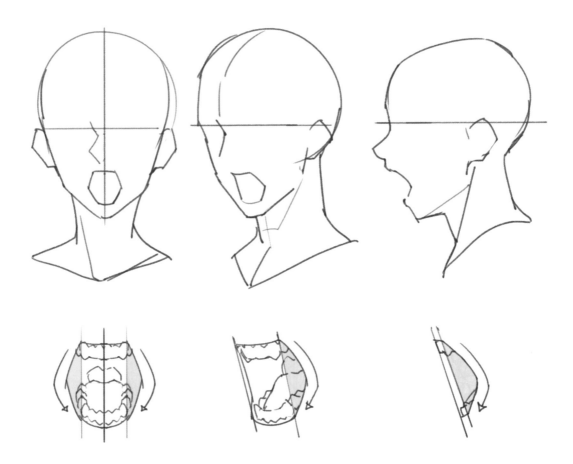

當張大嘴巴的時候，嘴角末端的空間會
呈三角形狀。

When the mouth is wide open, the
space at the end of the mouth is set in a
triangular shape.

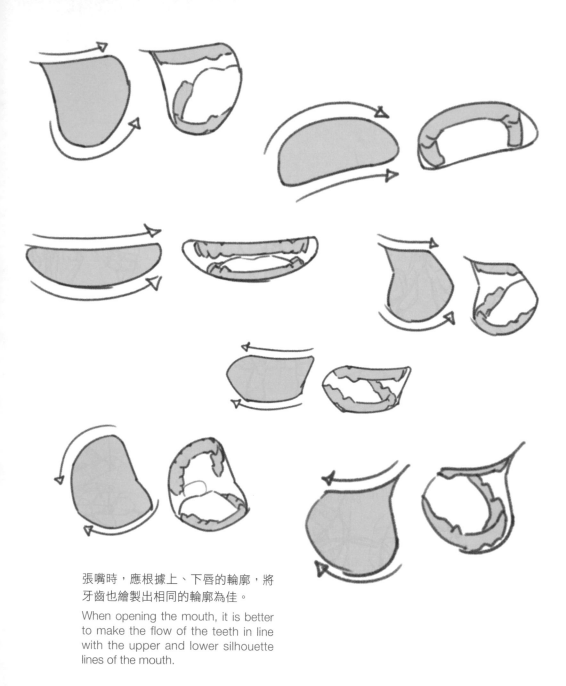

張嘴時，應根據上、下唇的輪廓，將牙齒也繪製出相同的輪廓為佳。

When opening the mouth, it is better to make the flow of the teeth in line with the upper and lower silhouette lines of the mouth.

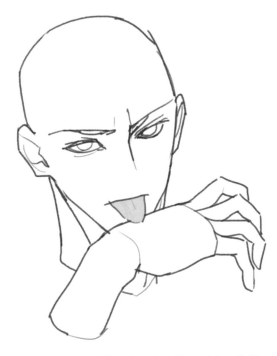

在舌頭內側中央畫出中央線，形成凹陷狀，愈往
舌尖處，中央線就愈薄，逐漸消失。

The inner part of the tongue is curved by drawing
a line in the middle. As it comes to the tip of the
tongue, the middle line disappears and the tongue
becomes thinner.

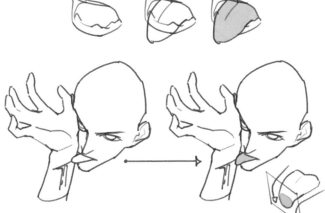

以舌頭碰觸物體時，應使
舌尖微微凹折。

When the tongue touches
something, slightly bend
the tip of the tongue.

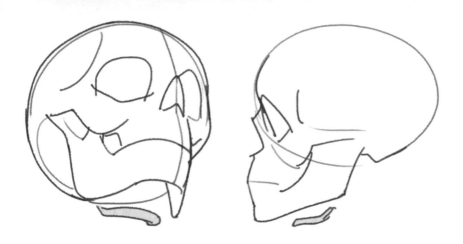

由於位於下巴底部的舌骨形狀，臉部和
頸部交界處會形成彎折的構造。

The tongue bone located under the
creates a structure that is bent at the
border of the face and neck.

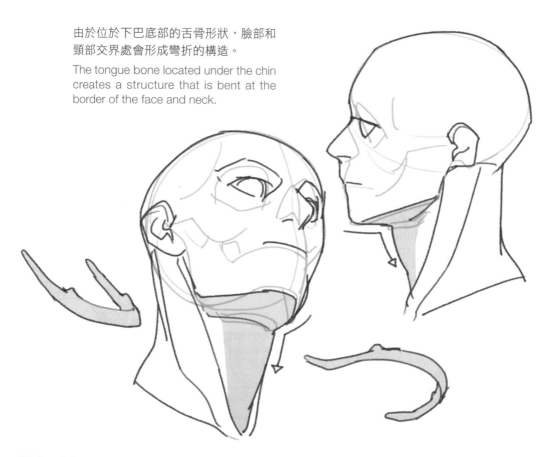

抬高臉部時，下巴傾斜的角度應為下巴位置往耳朵底部繪製一條向上的斜線。此時就能形成一個三角型的空間。

The angle at which the chin bends when the face is lifted is the same as the angle of the triangle that occurs when a diagonal line is drawn from the chin to the ear.

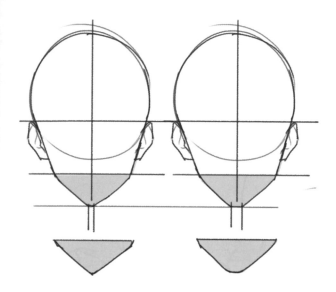

單是改變下巴的形狀，就能輕鬆
表現出各種不同的臉型。

It is easy to express various facial
shapes with just the area of the
chin.

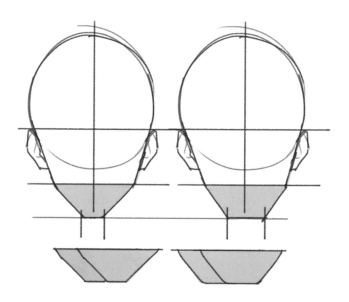

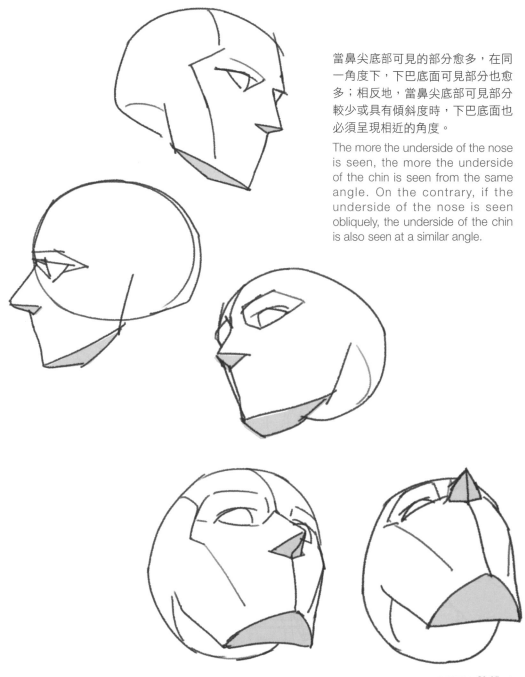

當鼻尖底部可見的部分愈多，在同一角度下，下巴底面可見部分也愈多；相反地，當鼻尖底部可見部分較少或具有傾斜度時，下巴底面也必須呈現相近的角度。

The more the underside of the nose is seen, the more the underside of the chin is seen from the same angle. On the contrary, if the underside of the nose is seen obliquely, the underside of the chin is also seen at a similar angle.

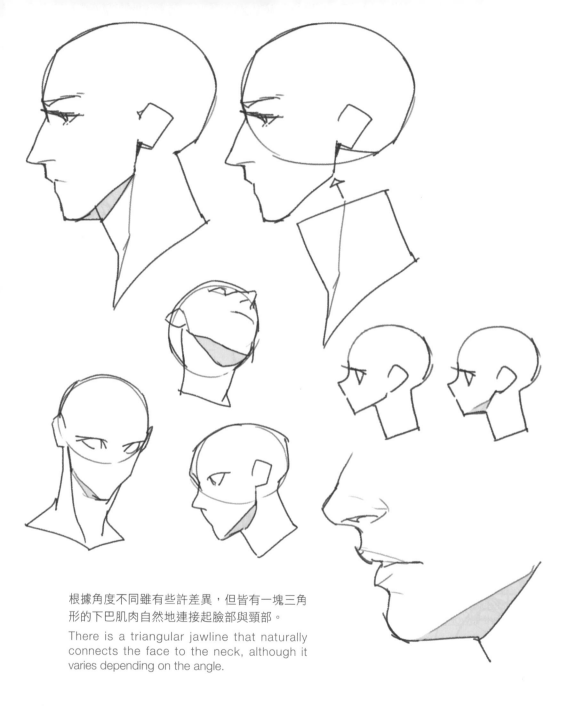

根據角度不同雖有些許差異，但皆有一塊三角形的下巴肌肉自然地連接起臉部與頸部。

There is a triangular jawline that naturally connects the face to the neck, although it varies depending on the angle.

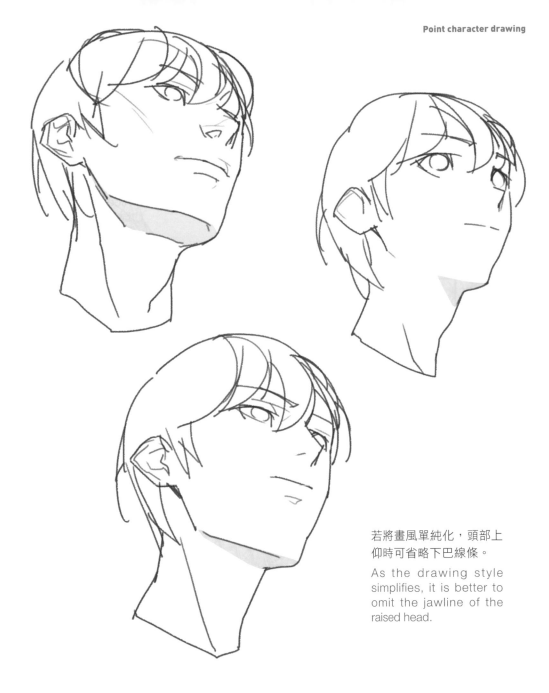

若將畫風單純化，頭部上仰時可省略下巴線條。

As the drawing style simplifies, it is better to omit the jawline of the raised head.

根據不同畫風的表現方式，繪製低角度時，可省略下巴底部的形狀，
使畫面更單純。

Depending on the drawing style, the area under the chin may be simply
omitted when the angle is low.

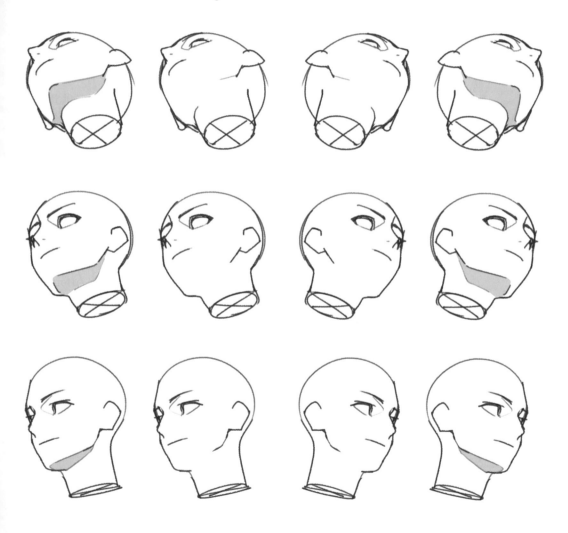

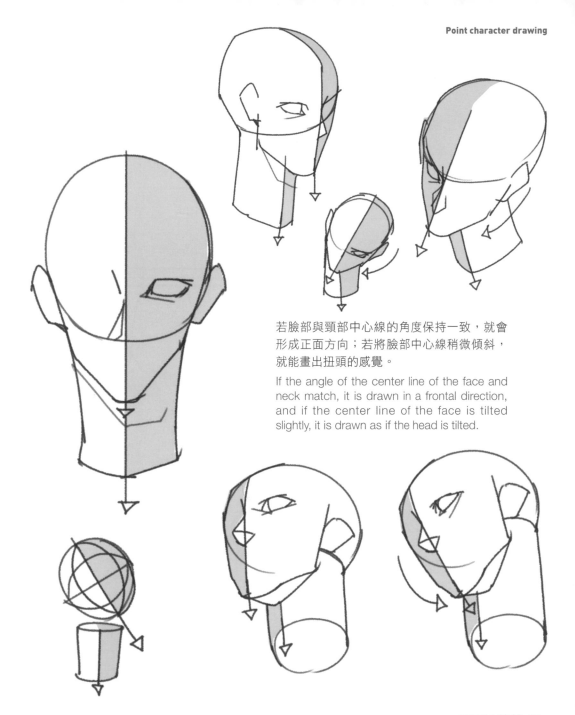

若臉部與頸部中心線的角度保持一致，就會
形成正面方向；若將臉部中心線稍微傾斜，
就能畫出扭頭的感覺。

If the angle of the center line of the face and
neck match, it is drawn in a frontal direction,
and if the center line of the face is tilted
slightly, it is drawn as if the head is tilted.

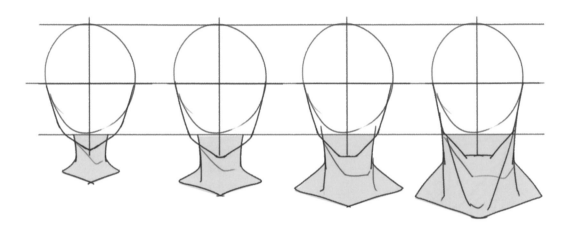

根據想表現的風格不同，臉型上應同時改變脖子長度
與厚度，使其保持一致。

Match the length and thickness of the neck to the
style and shape of the face.

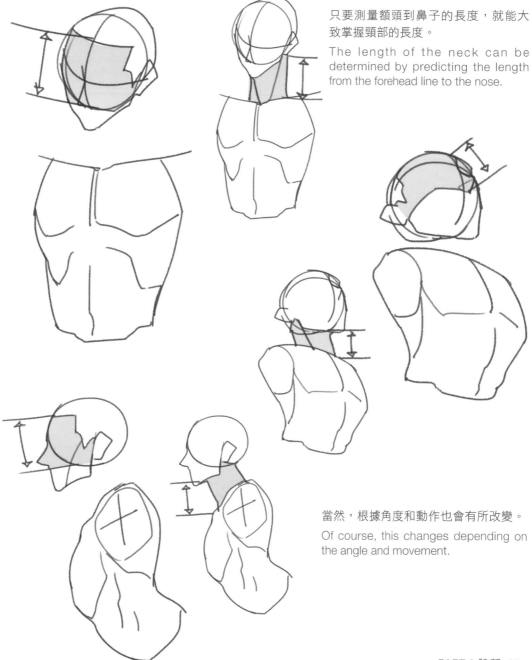

只要測量額頭到鼻子的長度，就能大致掌握頸部的長度。

The length of the neck can be determined by predicting the length from the forehead line to the nose.

當然，根據角度和動作也會有所改變。

Of course, this changes depending on the angle and movement.

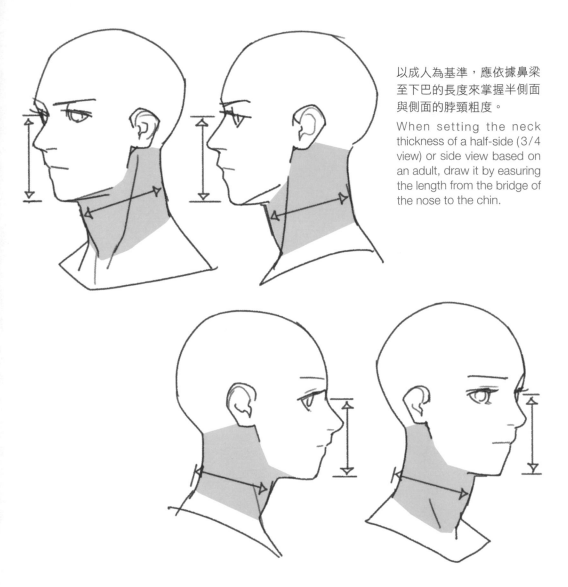

以成人為基準,應依據鼻梁至下巴的長度來掌握半側面與側面的脖頸粗度。

When setting the neck thickness of a half-side (3/4 view) or side view based on an adult, draw it by easuring the length from the bridge of the nose to the chin.

以女性的情況來説,脖頸可比男性更細一些。

For women, it makes their necks a little thinner than men.

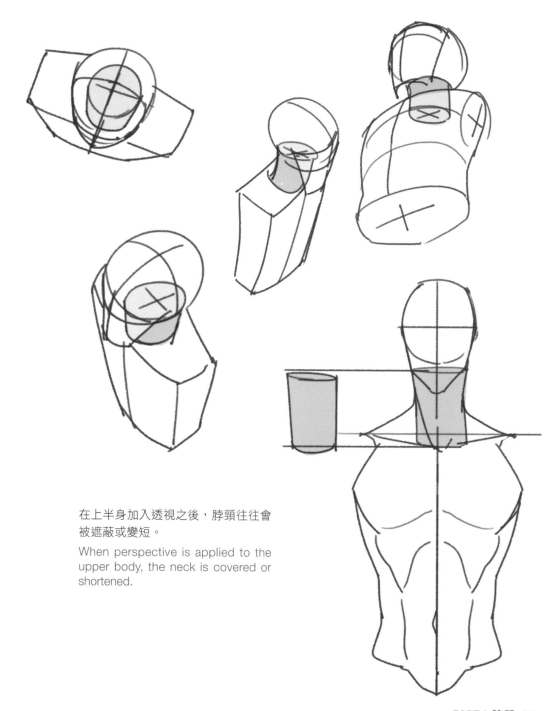

在上半身加入透視之後，脖頸往往會
被遮蔽或變短。

When perspective is applied to the
upper body, the neck is covered or
shortened.

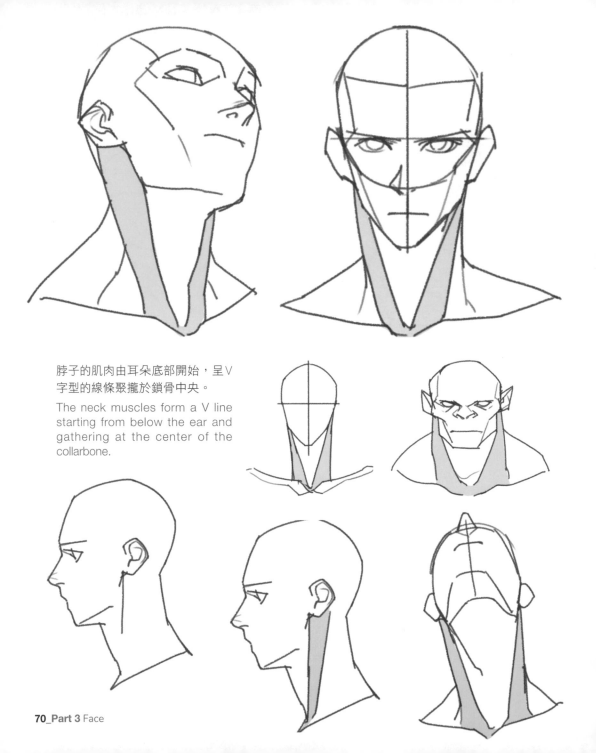

脖子的肌肉由耳朵底部開始，呈V字型的線條聚攏於鎖骨中央。

The neck muscles form a V line starting from below the ear and gathering at the center of the collarbone.

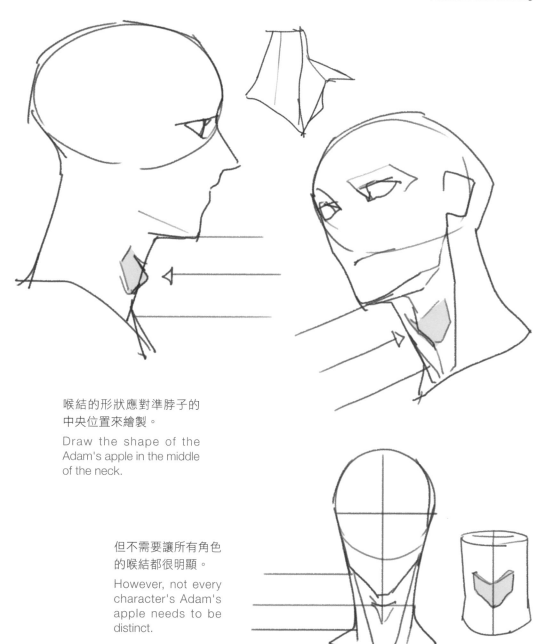

喉結的形狀應對準脖子的
中央位置來繪製。

Draw the shape of the
Adam's apple in the middle
of the neck.

但不需要讓所有角色
的喉結都很明顯。

However, not every
character's Adam's
apple needs to be
distinct.

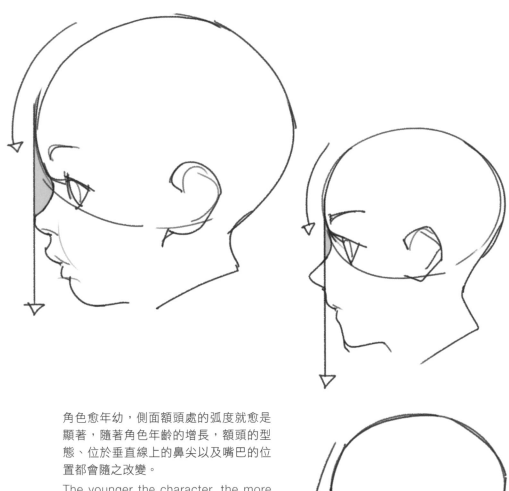

角色愈年幼，側面額頭處的弧度就愈是顯著，隨著角色年齡的增長，額頭的型態、位於垂直線上的鼻尖以及嘴巴的位置都會隨之改變。

The younger the character, the more curved the forehead from the side. And as the character ages, the position of the nose and mouth on the vertical line and the shape of the forehead change.

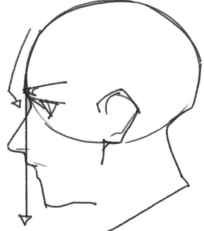

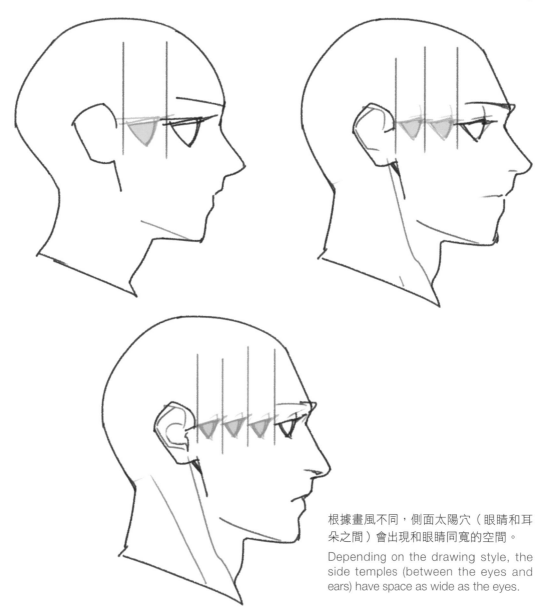

根據畫風不同，側面太陽穴（眼睛和耳朵之間）會出現和眼睛同寬的空間。

Depending on the drawing style, the side temples (between the eyes and ears) have space as wide as the eyes.

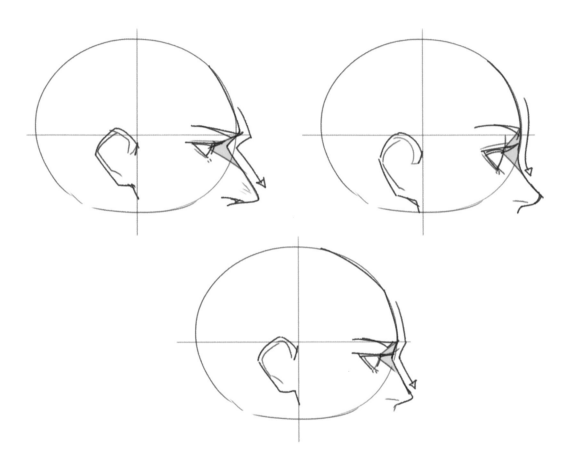

根據眉間凹折的角度，角色的形象有可能顯得
柔和或者強悍。

Depending on the angle at which the wrinkles
between the eyebrows are bent, the impression
may be softened or strengthened.

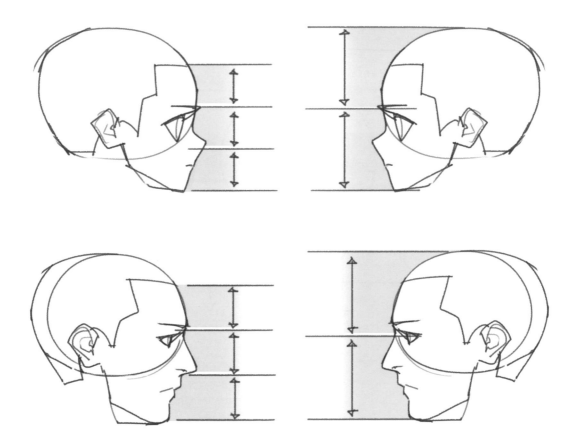

即使是相同的圖樣，如何掌握比例都因人而異，
並沒有絕對的正解。

Even in the same form, it is up to the person who
figures out the proportion and draws it. There is
no right or wrong answer.

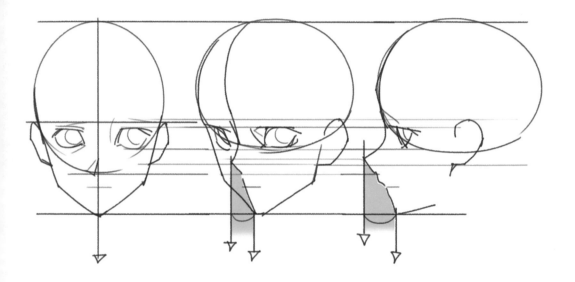

從正面觀看，鼻子和下巴的位置一致，由半側面和側面觀察，下巴的位置則比鼻尖更靠後。

The position of the nose and chin on the front face is consistent, and the position of the chin is behind the nose on the half-side (three quarter side) and the side face.

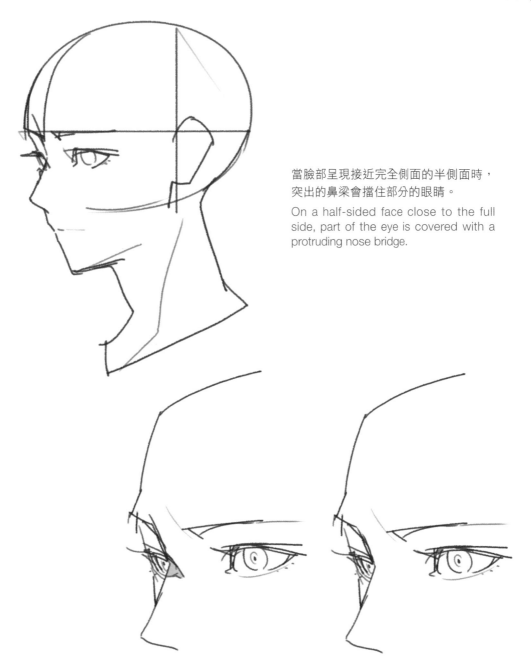

當臉部呈現接近完全側面的半側面時，
突出的鼻梁會擋住部分的眼睛。

On a half-sided face close to the full
side, part of the eye is covered with a
protruding nose bridge.

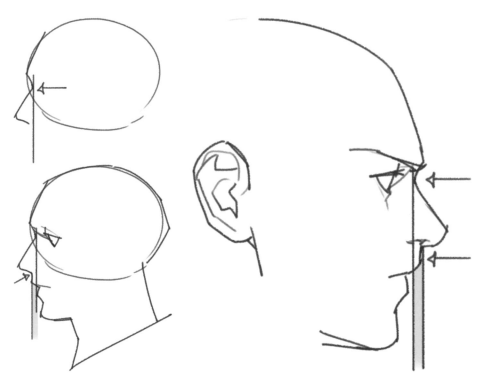

繪製臉部側面時，人中的位置應比鼻梁的起點更突出些許。

When drawing the side of the face, draw the philtrum a little more forward than the starting point of the nose.

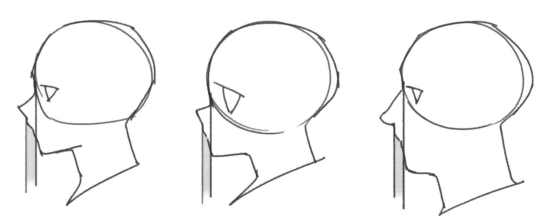

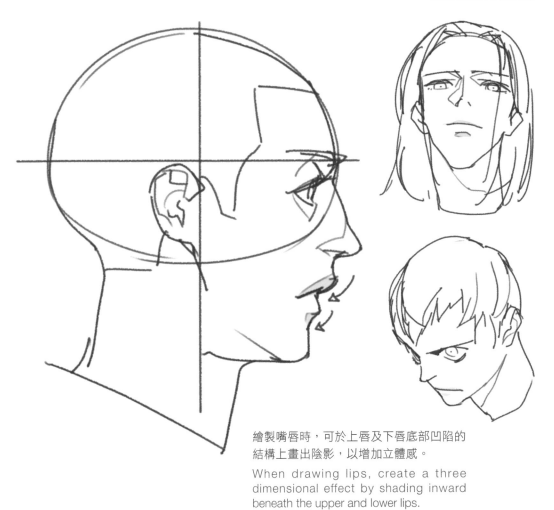

繪製嘴唇時，可於上唇及下唇底部凹陷的
結構上畫出陰影，以增加立體感。

When drawing lips, create a three
dimensional effect by shading inward
beneath the upper and lower lips.

亦能以陰影的形狀塑造出風格的差異。

The depth of shading creates different
effects.

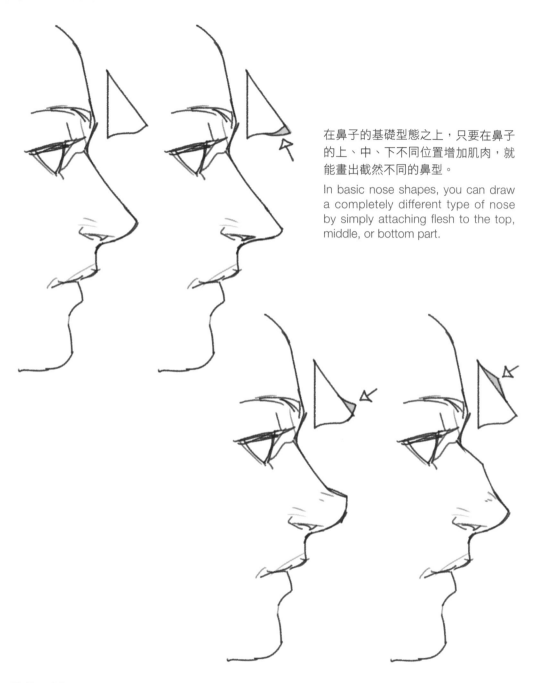

在鼻子的基礎型態之上，只要在鼻子的上、中、下不同位置增加肌肉，就能畫出截然不同的鼻型。

In basic nose shapes, you can draw a completely different type of nose by simply attaching flesh to the top, middle, or bottom part.

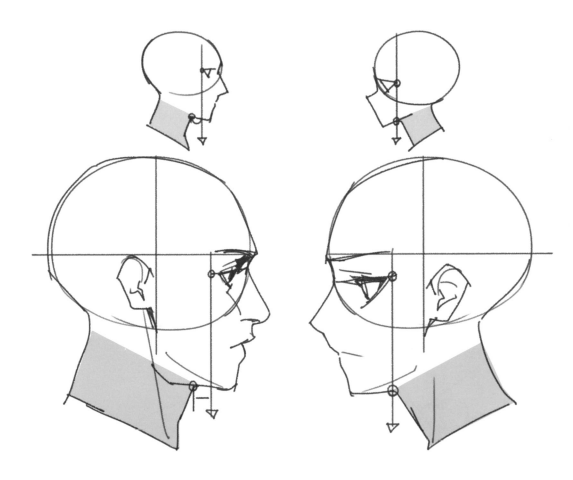

在側面的臉部上，連接眼角至下巴畫出一條垂直線，再根據畫風差異留出適當的間距，即可找出頸部的起始位置。

When drawing the side of the face, draw a vertical line from the tail of the eye to the chin. Depending on the drawing style, change the space between the starting point of the neck and the vertical line.

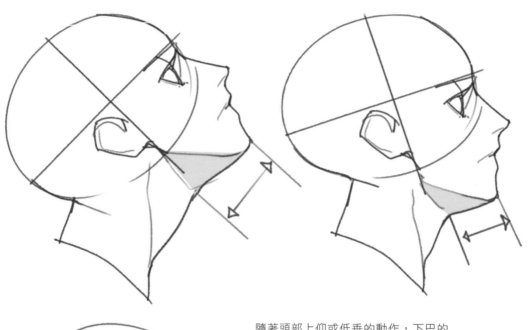

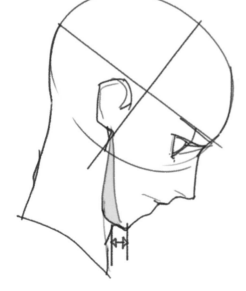

隨著頭部上仰或低垂的動作，下巴的
長度會有所不同。

Raising or lowering the head changes
the length under the chin.

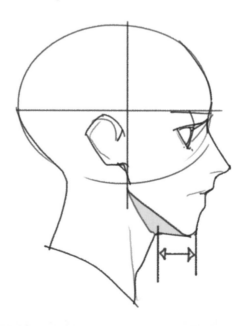

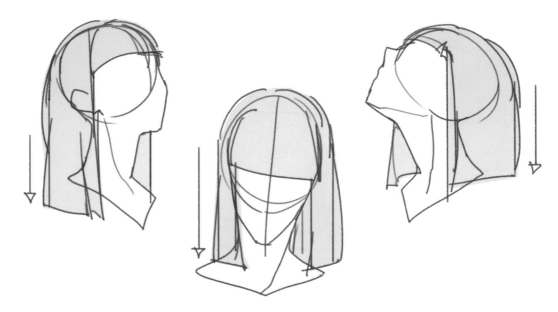

由於重力影響，基本上頭髮會保持
垂直向下的狀態。

Hair falls vertically down following
gravity.

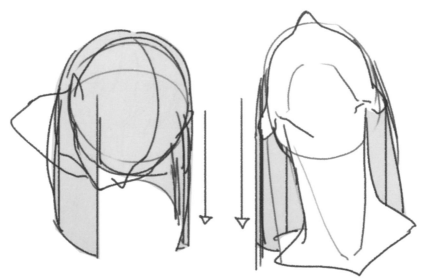

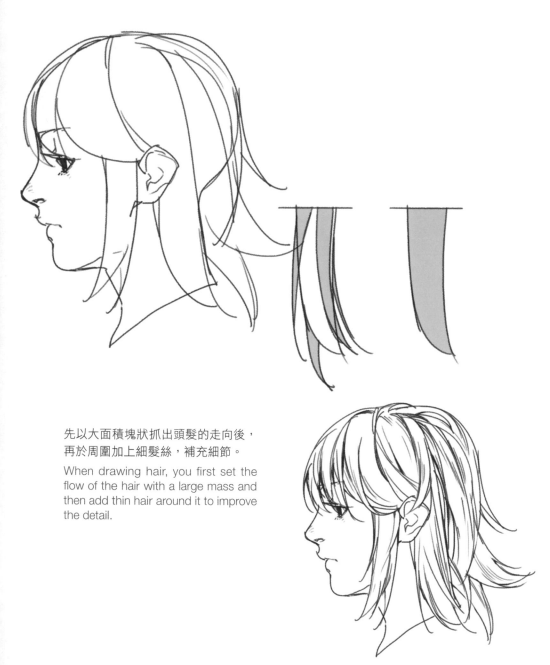

先以大面積塊狀抓出頭髮的走向後，
再於周圍加上細髮絲，補充細節。

When drawing hair, you first set the
flow of the hair with a large mass and
then add thin hair around it to improve
the detail.

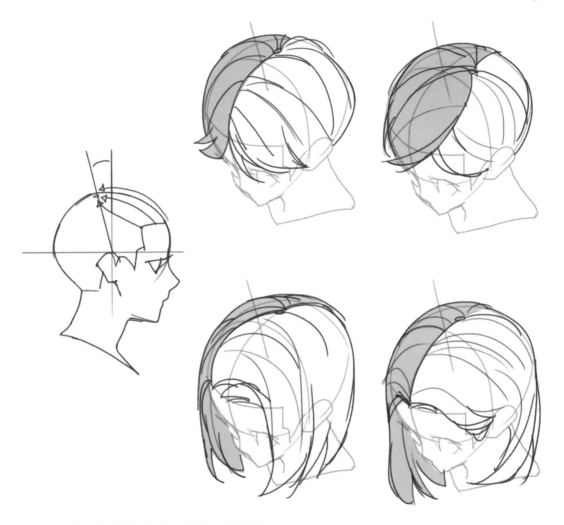

髮縫末端的髮旋部分，最好定於頭頂正
中央稍微偏後的位置。

Set the end of the side parting at the
crown of the head, slightly back from
the center.

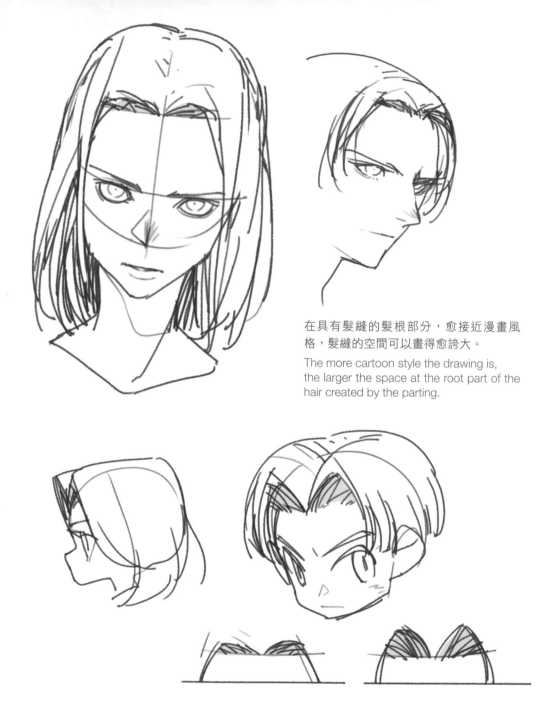

在具有髮縫的髮根部分，愈接近漫畫風格，髮縫的空間可以畫得愈誇大。

The more cartoon style the drawing is, the larger the space at the root part of the hair created by the parting.

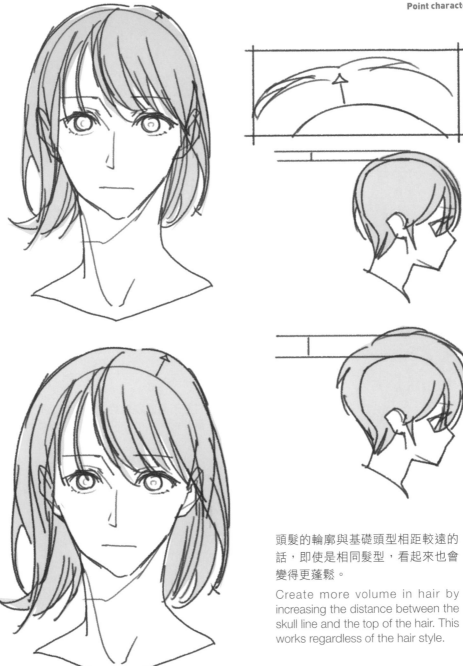

頭髮的輪廓與基礎頭型相距較遠的話，即使是相同髮型，看起來也會變得更蓬鬆。

Create more volume in hair by increasing the distance between the skull line and the top of the hair. This works regardless of the hair style.

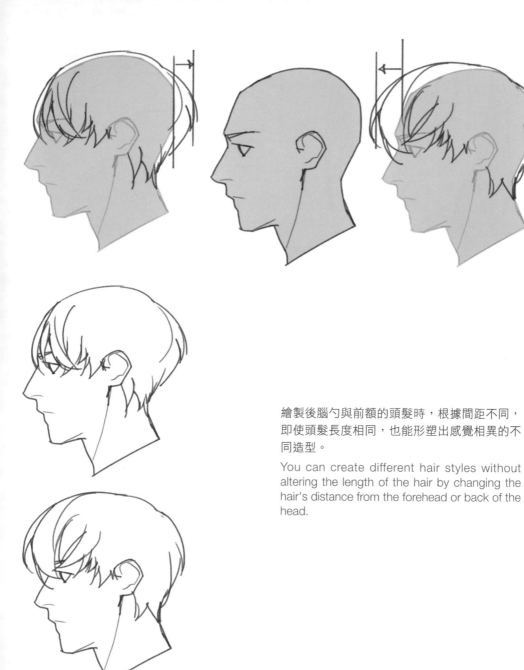

繪製後腦勺與前額的頭髮時，根據間距不同，即使頭髮長度相同，也能形塑出感覺相異的不同造型。

You can create different hair styles without altering the length of the hair by changing the hair's distance from the forehead or back of the head.

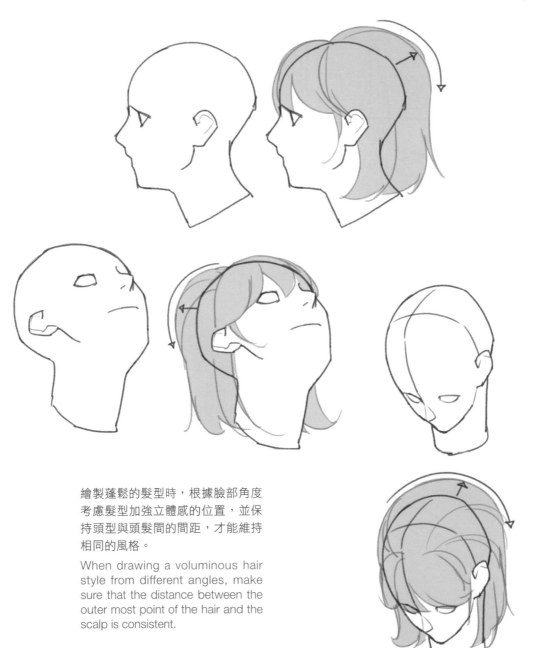

繪製蓬鬆的髮型時，根據臉部角度考慮髮型加強立體感的位置，並保持頭型與頭髮間的間距，才能維持相同的風格。

When drawing a voluminous hair style from different angles, make sure that the distance between the outer most point of the hair and the scalp is consistent.

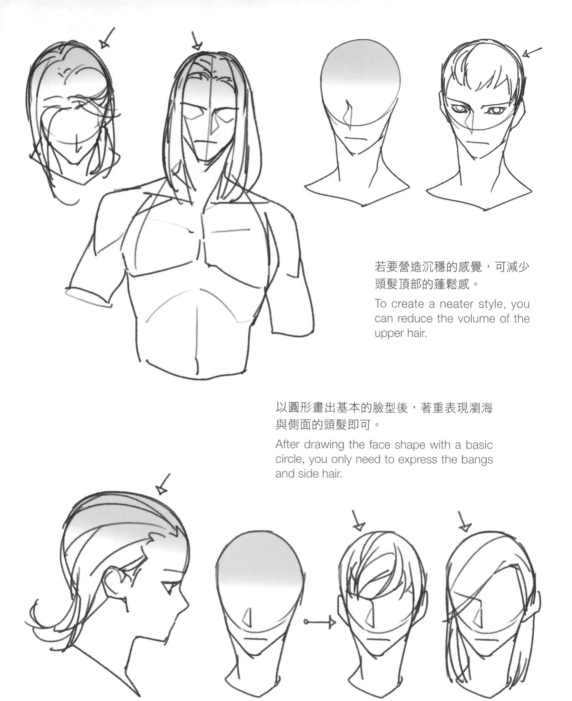

若要營造沉穩的感覺，可減少
頭髮頂部的蓬鬆感。

To create a neater style, you
can reduce the volume of the
upper hair.

以圓形畫出基本的臉型後，著重表現瀏海
與側面的頭髮即可。

After drawing the face shape with a basic
circle, you only need to express the bangs
and side hair.

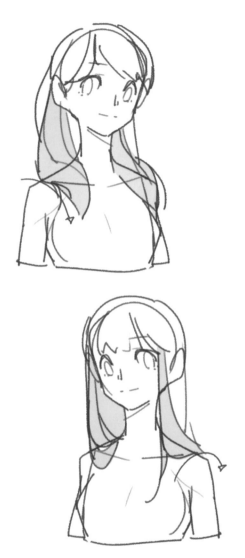

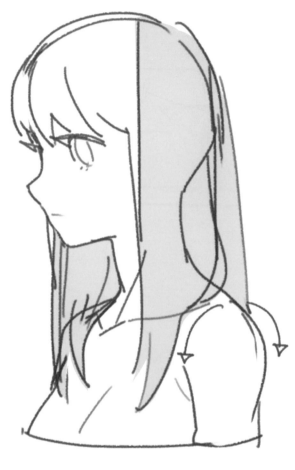

當長髮撥向前方或披在後側時，強調出披掛在肩膀上的髮流，才能形塑立體感。

For long hair, you need to draw a curve that flows across the shoulder to create a three-dimensional effect.

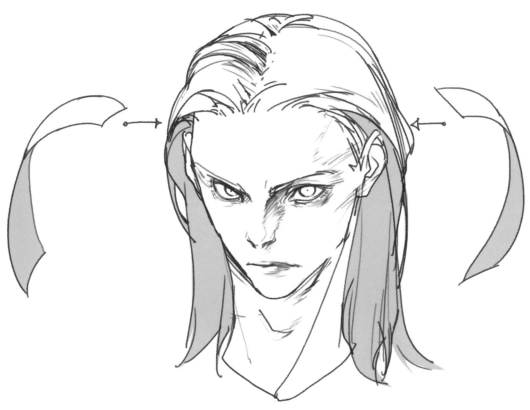

繪製撥向後側的長髮時，畫出頭髮的內
側才能表現出立體感。

When drawing long hair that is turned
back, showing the side of the inner hair
creates a three-dimensional effect.

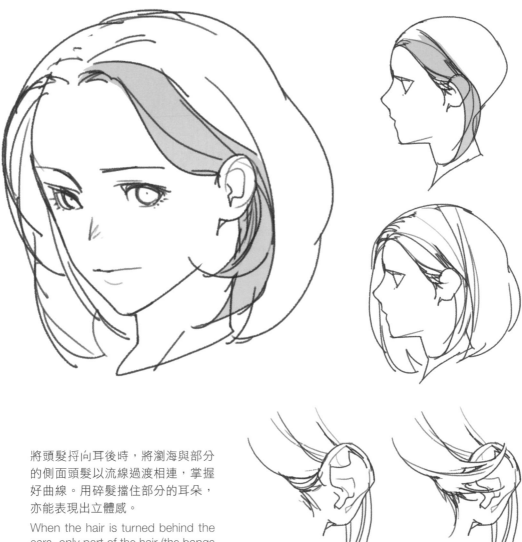

將頭髮捋向耳後時，將瀏海與部分
的側面頭髮以流線過渡相連，掌握
好曲線。用碎髮擋住部分的耳朵，
亦能表現出立體感。

When the hair is turned behind the
ears, only part of the hair (the bangs
and side hair) is used to create
a curve flowing behind the ears.
Covering part of the ears with fine
hair gives a three-dimensional effect.

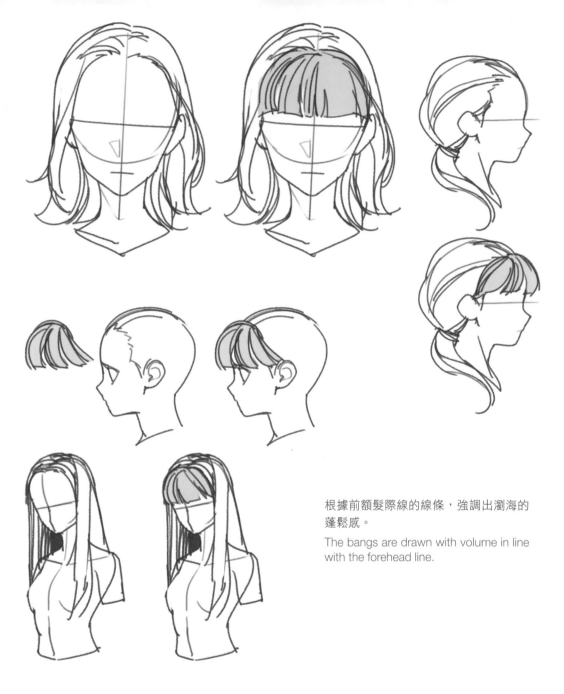

根據前額髮際線的線條，強調出瀏海的蓬鬆感。

The bangs are drawn with volume in line with the forehead line.

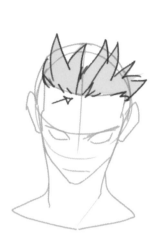
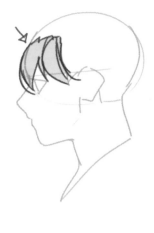
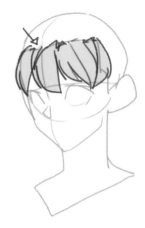

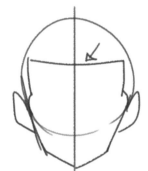

瀏海的長度和髮流是由前額髮際線處開始的，只是以頂部的頭髮自然掩蓋住而已。（若瀏海向後梳則反之。）

The length and flow of the bangs begins from the forehead line, which is visible when the hair is swept back. When swept forward, the forehead line is covered by the upper hair.

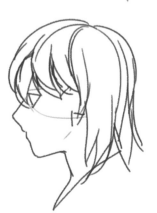

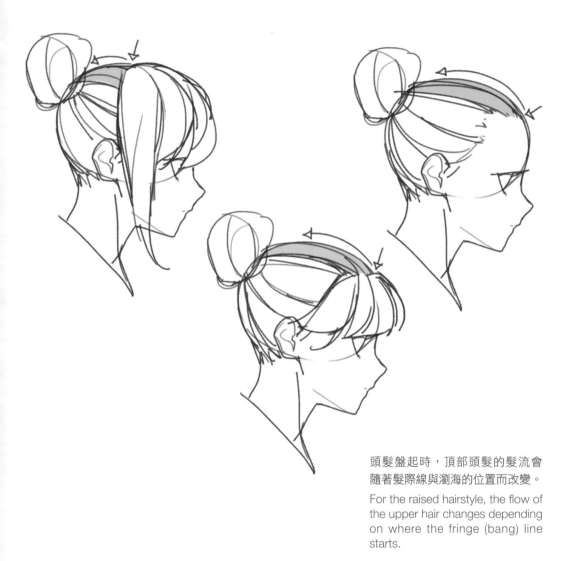

頭髮盤起時，頂部頭髮的髮流會
隨著髮際線與瀏海的位置而改變。

For the raised hairstyle, the flow of
the upper hair changes depending
on where the fringe (bang) line
starts.

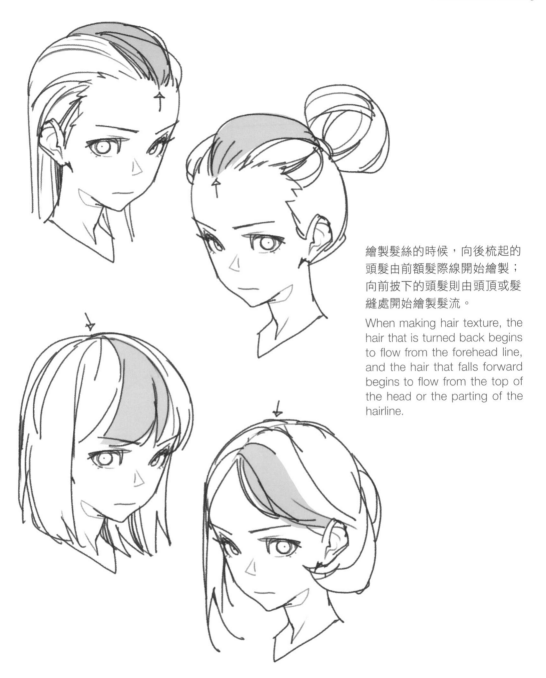

繪製髮絲的時候，向後梳起的
頭髮由前額髮際線開始繪製；
向前披下的頭髮則由頭頂或髮
縫處開始繪製髮流。

When making hair texture, the
hair that is turned back begins
to flow from the forehead line,
and the hair that falls forward
begins to flow from the top of
the head or the parting of the
hairline.

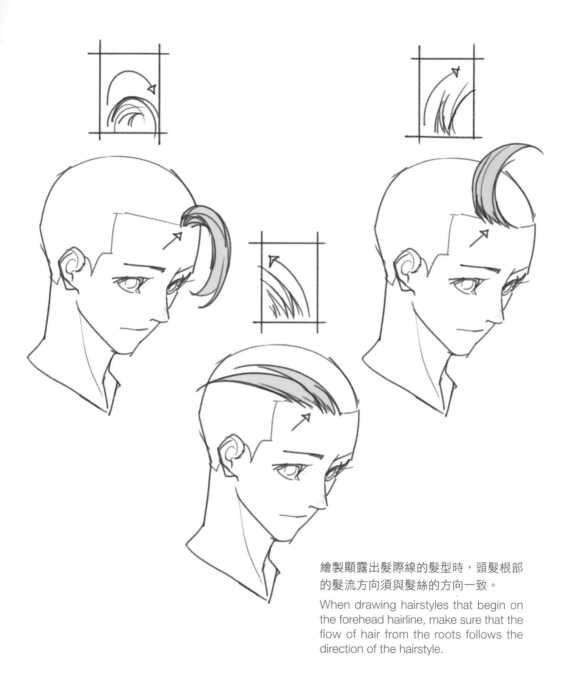

繪製顯露出髮際線的髮型時，頭髮根部的髮流方向須與髮絲的方向一致。

When drawing hairstyles that begin on the forehead hairline, make sure that the flow of hair from the roots follows the direction of the hairstyle.

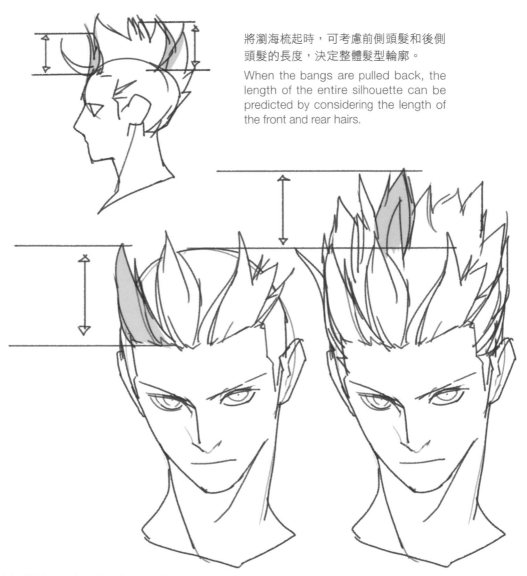

將瀏海梳起時，可考慮前側頭髮和後側頭髮的長度，決定整體髮型輪廓。

When the bangs are pulled back, the length of the entire silhouette can be predicted by considering the length of the front and rear hairs.

這幅範例顯示出角色頭部低垂時，後側頭髮整體輪廓被提高的狀態。

In this picture, the silhouette of the rear hair is raised as the head is lowered.

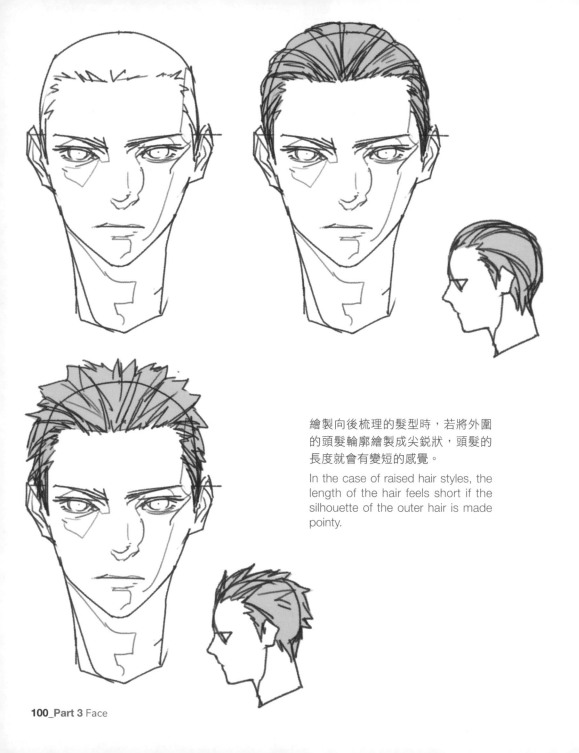

繪製向後梳理的髮型時，若將外圍
的頭髮輪廓繪製成尖銳狀，頭髮的
長度就會有變短的感覺。

In the case of raised hair styles, the
length of the hair feels short if the
silhouette of the outer hair is made
pointy.

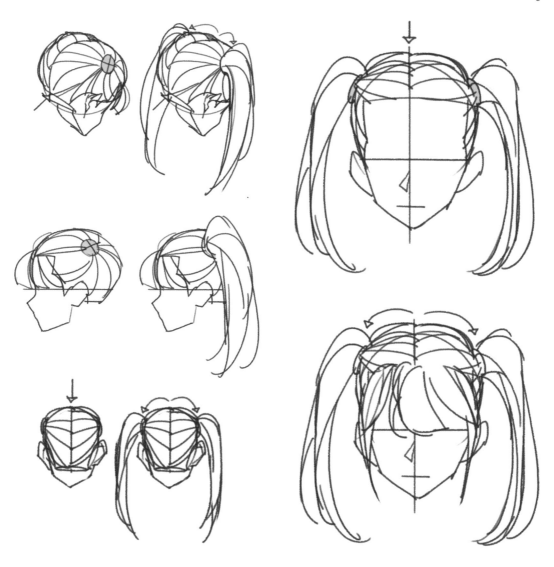

繪製雙馬尾髮型時，可先以中心線為基準將臉部5：5
平分，再將髮流統一往紮起髮束的位置收攏。

To draw twin-tail hairstyles, divide the hair into equal
parts based on the centerline of the face, and gather
the flow of hair to the tying positions.

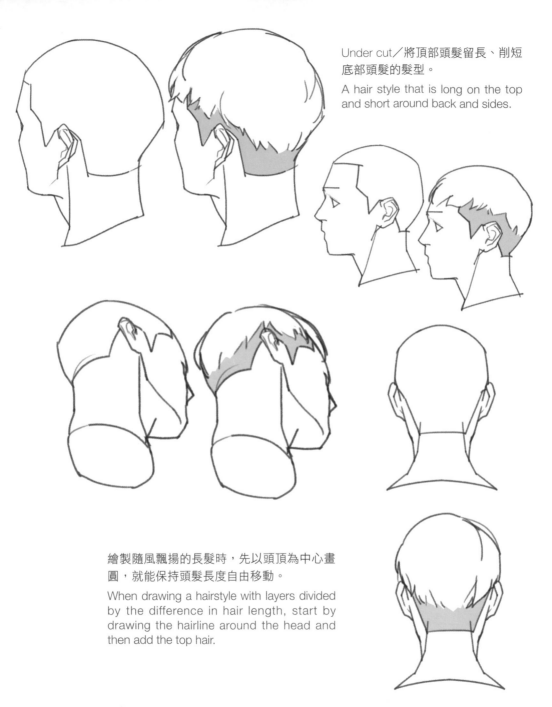

Under cut／將頂部頭髮留長、削短底部頭髮的髮型。

A hair style that is long on the top and short around back and sides.

繪製隨風飄揚的長髮時，先以頭頂為中心畫圓，就能保持頭髮長度自由移動。

When drawing a hairstyle with layers divided by the difference in hair length, start by drawing the hairline around the head and then add the top hair.

繪製隨風飄揚的長髮時，先以頭頂為中心畫圓，就能保持頭髮長度自由移動。

Long hair that swings wildly can be kept in proportion by drawing a circle around the top of the head.

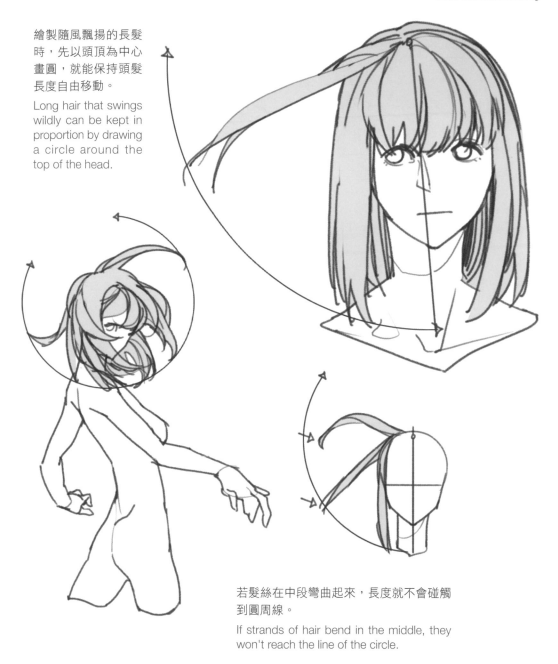

若髮絲在中段彎曲起來，長度就不會碰觸到圓周線。

If strands of hair bend in the middle, they won't reach the line of the circle.

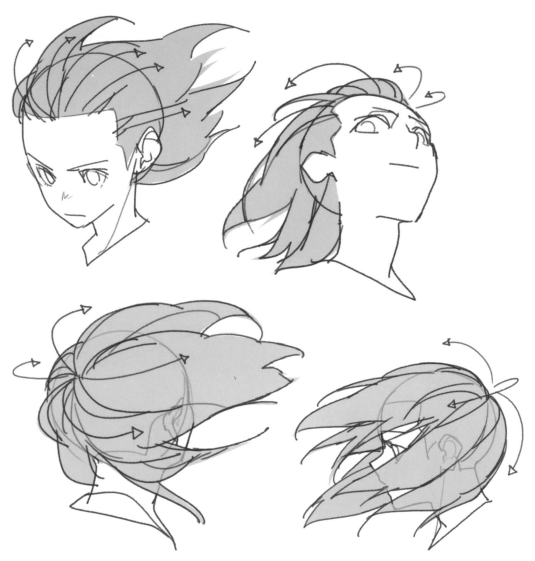

當風勢強勁時，正面的髮流會從額上髮際線
開始，背後則由頭頂髮旋向外延伸。

In strong wind, hair flows from the forehead
line at the front and from the top of the head
at the back.

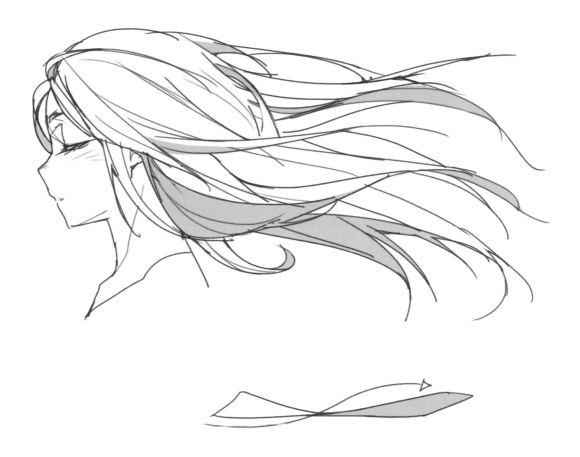

長髮隨風飛揚的情況下，同時畫出髮絲的內外兩面會更佳。
When long hair flies in the wind, it is good to show the inside and outside of the hair.

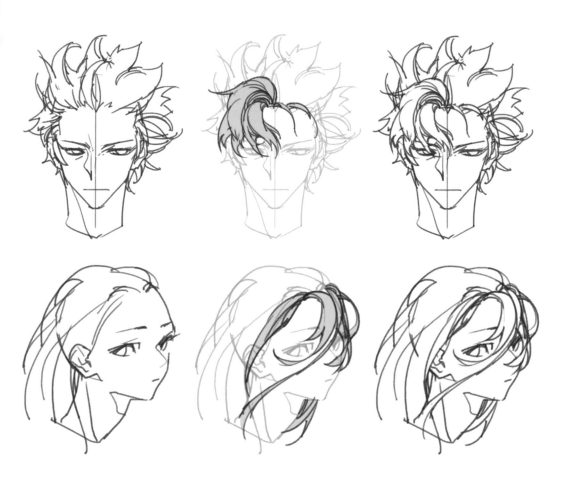

當髮絲飄散時，利用瀏海擋住額頭及部分的眼部，
就能極大化安靜沉穩的氛圍。

When the hair is scattered, cover the forehead and
part of the eyes with bangs to soften the face.

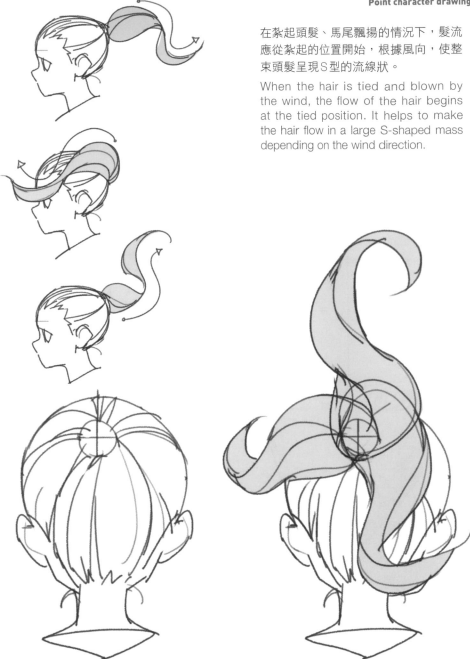

在紮起頭髮、馬尾飄揚的情況下，髮流應從紮起的位置開始，根據風向，使整束頭髮呈現S型的流線狀。

When the hair is tied and blown by the wind, the flow of the hair begins at the tied position. It helps to make the hair flow in a large S-shaped mass depending on the wind direction.

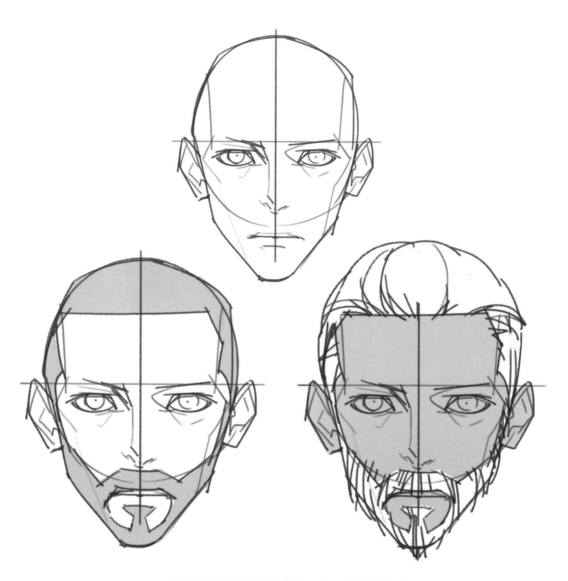

請參考鬍鬚可生長的範圍，按照範圍適當表現即
可。若鬍鬚長度較長，便有可能覆蓋住皮膚。

Determine the extent of the beard growth and draw
the beard accordingly. The fuller the beard, the more
skin surface is covered.

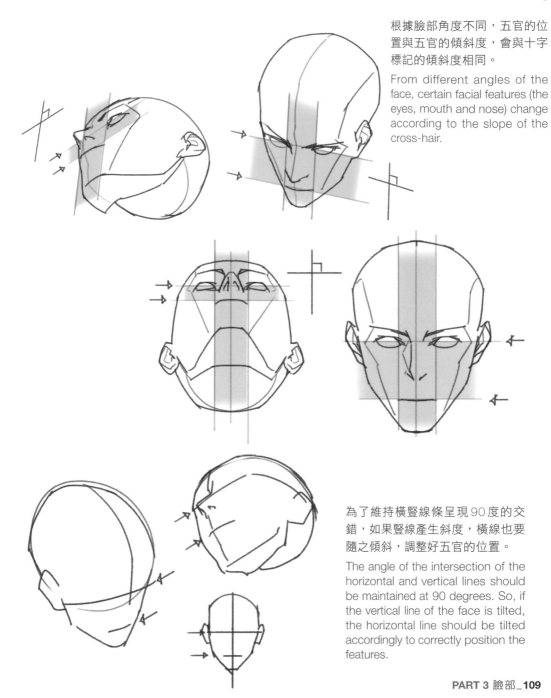

根據臉部角度不同，五官的位置與五官的傾斜度，會與十字標記的傾斜度相同。

From different angles of the face, certain facial features (the eyes, mouth and nose) change according to the slope of the cross-hair.

為了維持橫豎線條呈現90度的交錯，如果豎線產生斜度，橫線也要隨之傾斜，調整好五官的位置。

The angle of the intersection of the horizontal and vertical lines should be maintained at 90 degrees. So, if the vertical line of the face is tilted, the horizontal line should be tilted accordingly to correctly position the features.

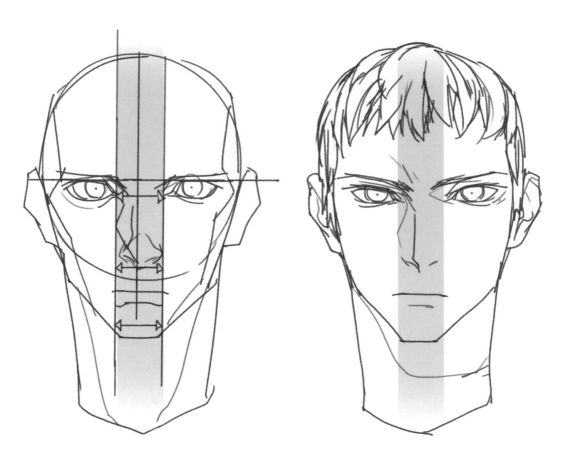

眉間、鼻翼與下巴的寬度雖然很相近，但可以根據角色設計及畫風
進行多樣的變化。

The width between the eyebrows, the width between the nose wings,
and the width of the chin are all similar, but they can vary depending
on the various character designs and drawing styles.

若想畫出可愛、個性強烈的臉部，
可以利用圖形化的方法。

To draw a unique and cute face, it is
helpful to draw it in figures.

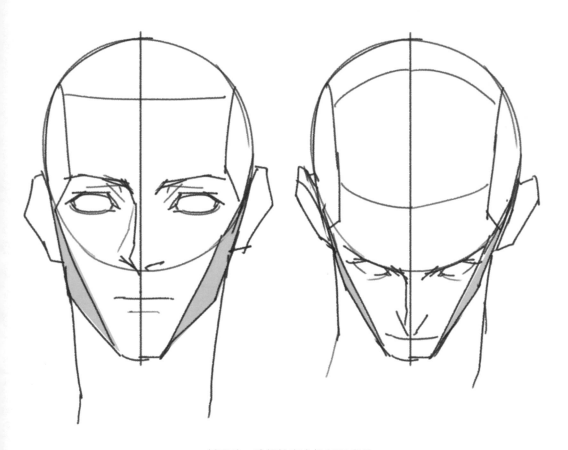

低頭時，臉部輪廓會拉得更瘦長。

Lowering the head makes the face
shape thinner.

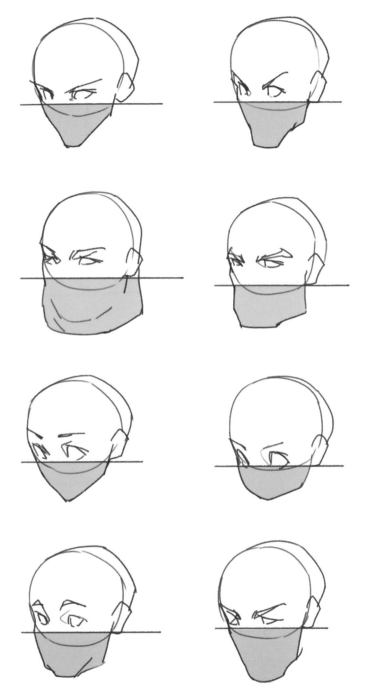

在表現多樣化的臉部造型時，下巴的輪廓起了很重要的作用。

The silhouette of the chin area plays an important role in expressing various faces.

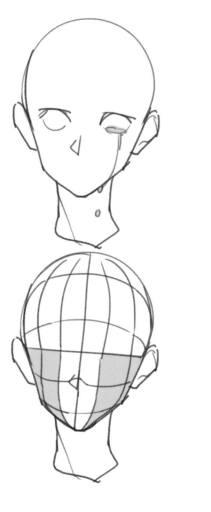

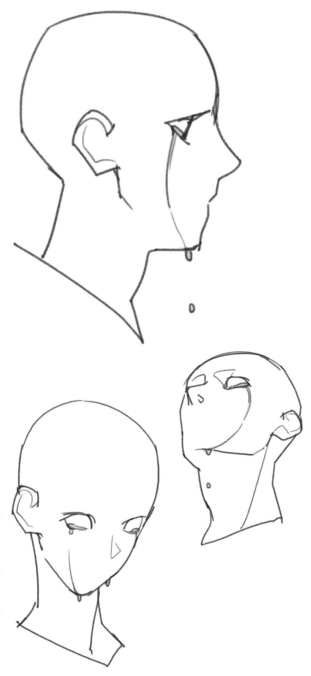

角色流淚時，比起直線，滴落的淚痕應
按照臉部曲線來繪製，淚痕較輕薄、滴
落的淚水則要型塑出厚度。

When tears flow, they are drawn along
the face curve rather than straight lines.
And tears flowing are expressed thinly,
while tears in the eyes are expressed by
creating a thickness.

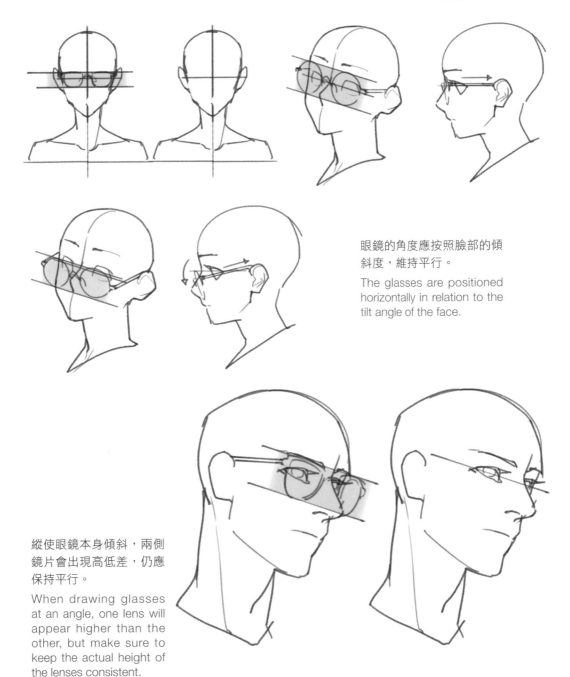

眼鏡的角度應按照臉部的傾斜度，維持平行。

The glasses are positioned horizontally in relation to the tilt angle of the face.

縱使眼鏡本身傾斜，兩側鏡片會出現高低差，仍應保持平行。

When drawing glasses at an angle, one lens will appear higher than the other, but make sure to keep the actual height of the lenses consistent.

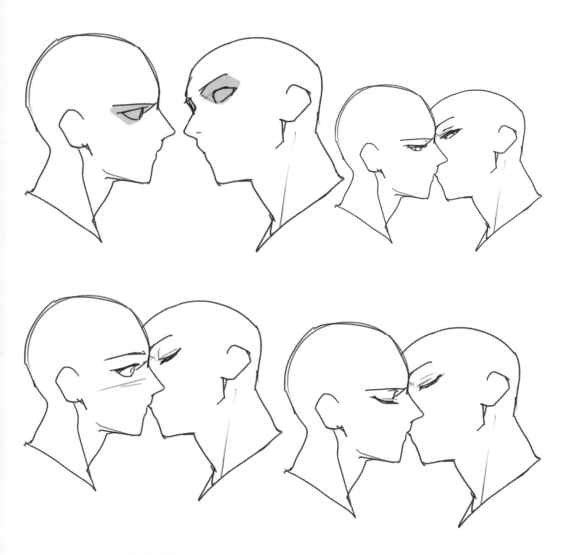

在相互親吻的動作中，能夠以多樣化的眼神表現出符合當
下狀況的情緒。

It is possible to express emotions appropriate to the
situation by expressing various eyes on the kissing face.

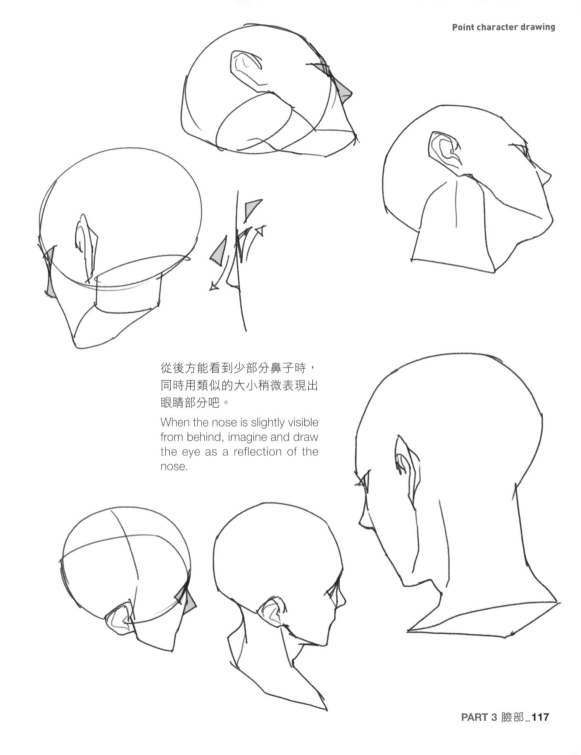

從後方能看到少部分鼻子時，
同時用類似的大小稍微表現出
眼睛部分吧。

When the nose is slightly visible
from behind, imagine and draw
the eye as a reflection of the
nose.

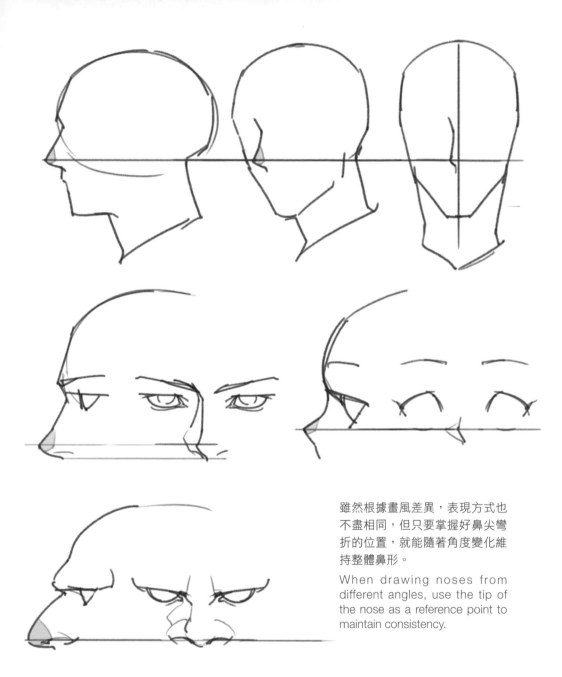

雖然根據畫風差異，表現方式也
不盡相同，但只要掌握好鼻尖彎
折的位置，就能隨著角度變化維
持整體鼻形。

When drawing noses from
different angles, use the tip of
the nose as a reference point to
maintain consistency.

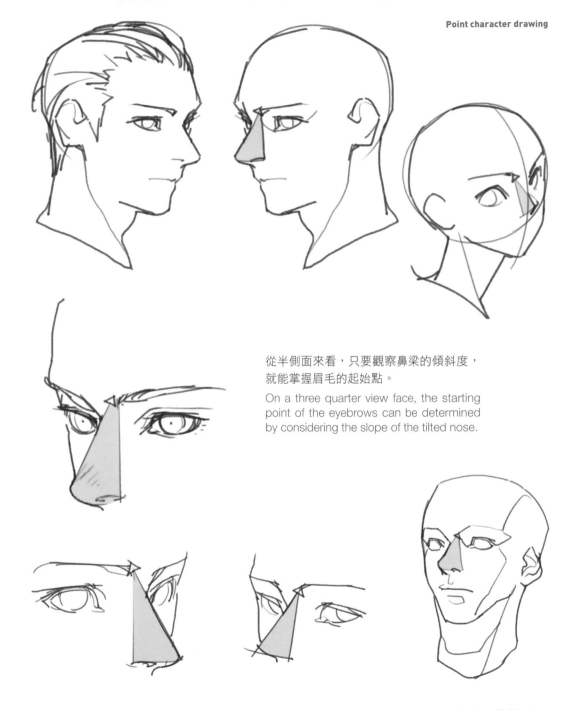

從半側面來看，只要觀察鼻梁的傾斜度，
就能掌握眉毛的起始點。

On a three quarter view face, the starting
point of the eyebrows can be determined
by considering the slope of the tilted nose.

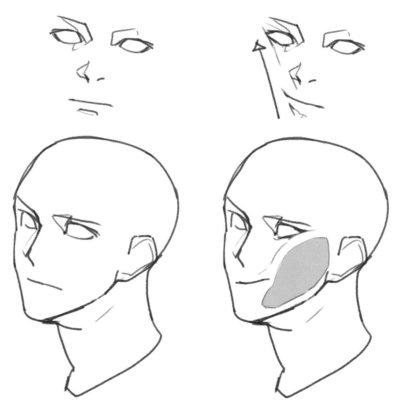

如果臉頰遭到擠壓，眼角和嘴角都
會隨之上揚。

When the cheeks are pushed upward, raise the tail of the eyes and the corners of the mouth.

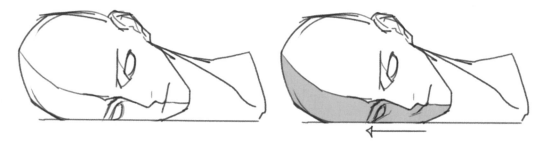

配戴帽子時，只要想像
出臉部的剖面圖，就能
輕易調整好角度。

When putting a hat on a character, you can adjust the angle between the hat and the face by picturing the cross section of the face.

若帽子角度與臉部剖面圖的角度
不同，就會變成斜戴的模樣。

If the cross-section of the face and the angle of the hat are different, it represents a hat worn at an angle.

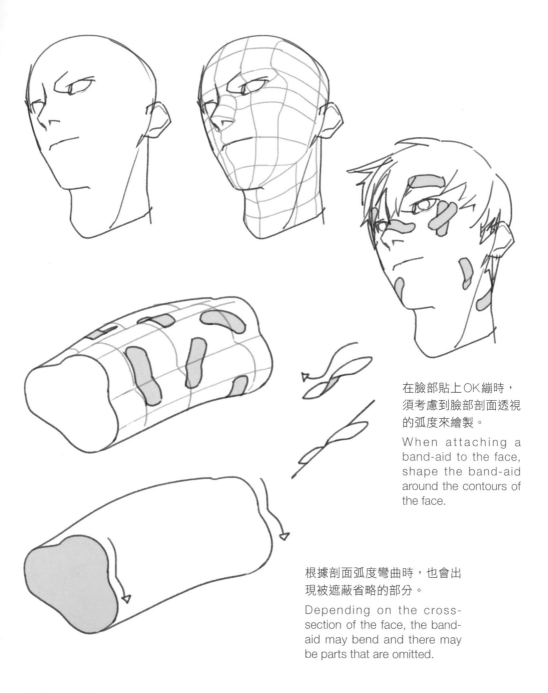

在臉部貼上OK繃時，
須考慮到臉部剖面透視
的弧度來繪製。

When attaching a
band-aid to the face,
shape the band-aid
around the contours of
the face.

根據剖面弧度彎曲時，也會出
現被遮蔽省略的部分。

Depending on the cross-
section of the face, the band-
aid may bend and there may
be parts that are omitted.

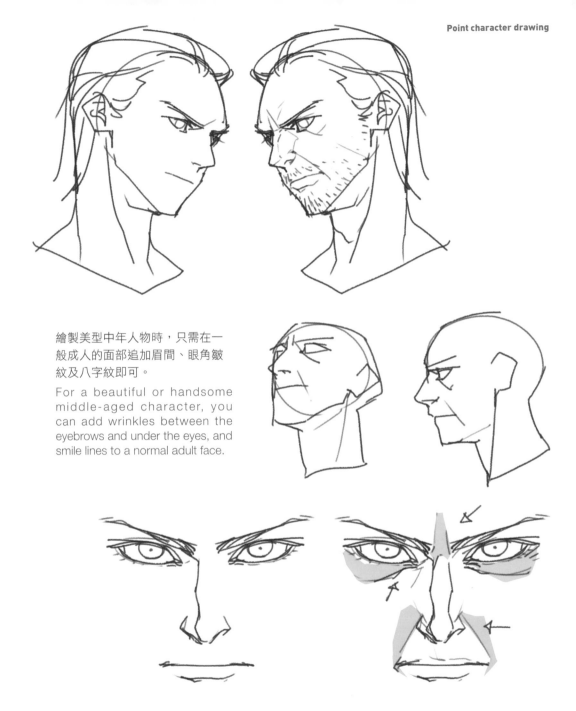

繪製美型中年人物時，只需在一般成人的面部追加眉間、眼角皺紋及八字紋即可。

For a beautiful or handsome middle-aged character, you can add wrinkles between the eyebrows and under the eyes, and smile lines to a normal adult face.

韓國繪師的角色繪製重點攻略

# Part 4 腿部

legs

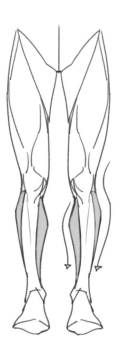

以八頭身而言，只要以臉部長度為基準，大腿、小腿分別對應臉部兩倍的長度，即可輕鬆繪製出腿部。

When drawing the legs based on the eight-head figure, the length of the thigh and the calf are the combined length of two faces.

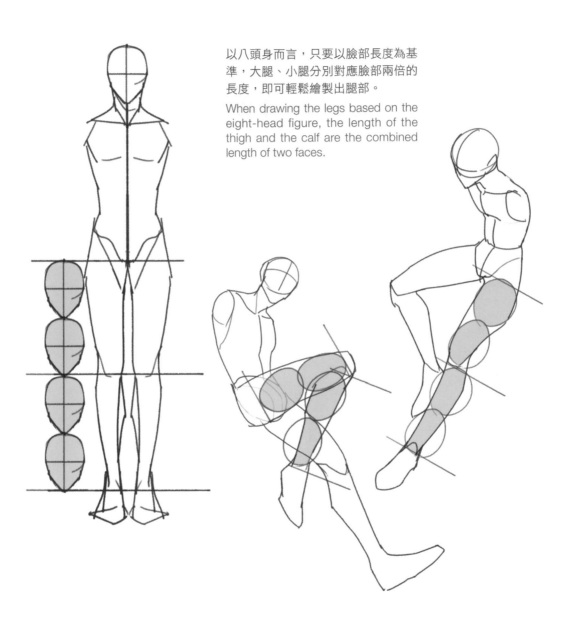

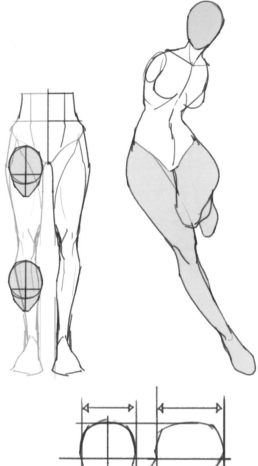

以成人而言，大腿的寬度約與頭部寬度類似，或比頭部略寬。小腿寬度則比頭度略窄。

By adult standards, the width of the thigh is equal to or wider than that of the head, and the width of calf is smaller than that of the head.

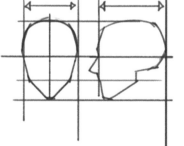

由於腿部正面和側面的寬度不同，繪製時須特別留意。

Since the width of the legs is different between the front and the side, draw the side view carefully.

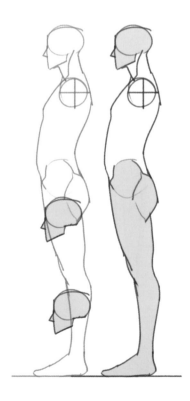

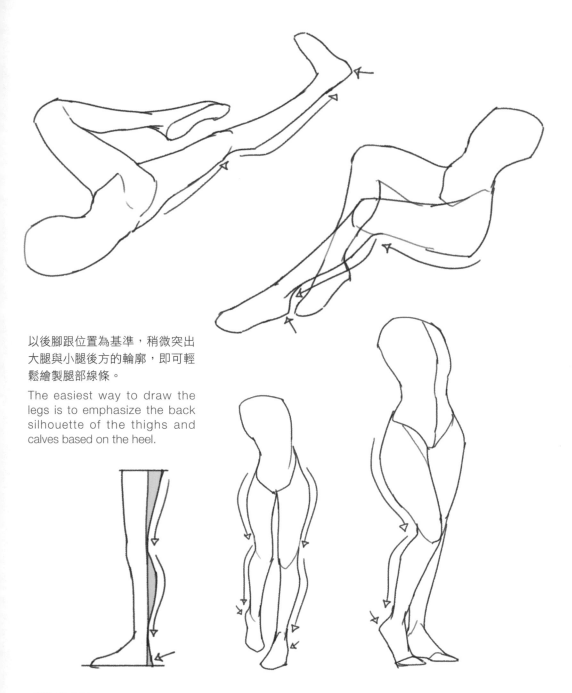

以後腳跟位置為基準，稍微突出大腿與小腿後方的輪廓，即可輕鬆繪製腿部線條。

The easiest way to draw the legs is to emphasize the back silhouette of the thighs and calves based on the heel.

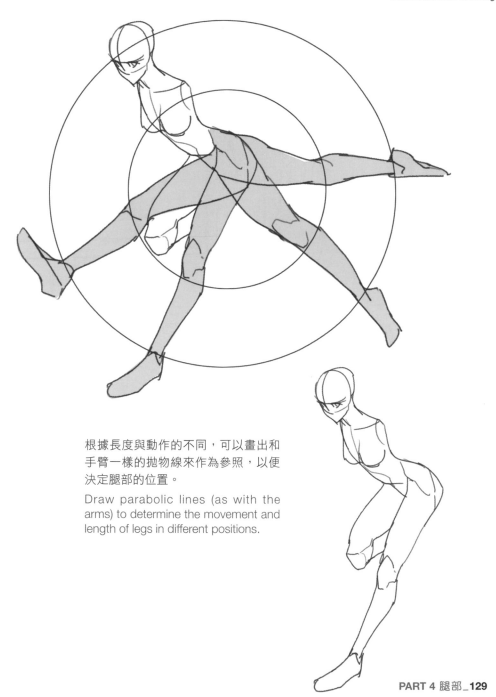

根據長度與動作的不同，可以畫出和
手臂一樣的拋物線來作為參照，以便
決定腿部的位置。

Draw parabolic lines (as with the
arms) to determine the movement and
length of legs in different positions.

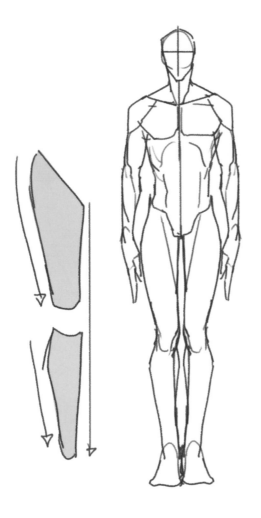

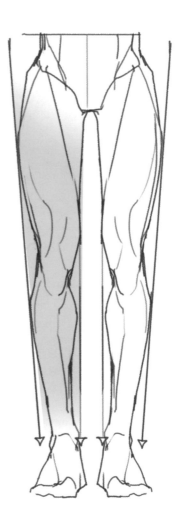

繪製腿部輪廓時，整體線條須形塑出內側
接近垂直、外側則略帶傾斜的角度。

When drawing the silhouette of the legs,
the inside of the legs is a vertical flow and
the outside is a slanted angle.

以半側面的站姿來看，僅僅調整靠近畫面一側的腿部線條，就能擴大腿部間距，形成差異。

In a standing position in the three quarter view,changing the flow of the leg nearest the screen will widen the stance.

若能刻畫出大腿內側三角形的
肌肉形狀，就能加強腿部線條
的細節。

Drawing a triangular muscle
on the inner side of the thigh
creates details on the leg lines.

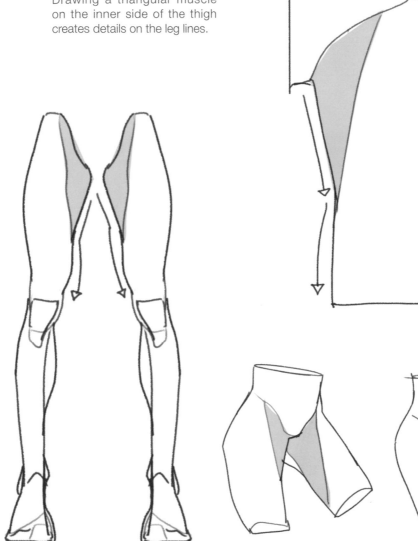

位於大腿後側的肌肉「大腿後肌（腿後腱）」大致分成兩塊肌群，但僅由皮膚表面來看無法顯著區分。

The muscles at the back of the thigh, called the hamstring, are divided into two. These are not easily visible on the surface.

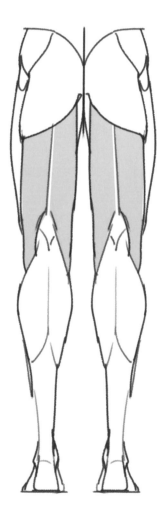

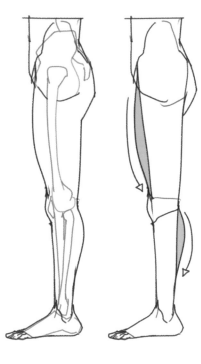

從側面觀察腿部時，應使大腿前側與小腿後側稍微隆起。

When looking at the legs from the side, it is good to add volume to the front of the thighs and back of the calves.

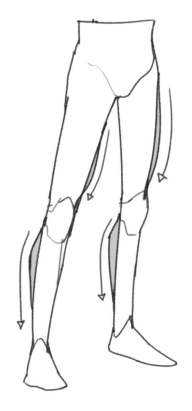

肌肉愈大，愈要加強隆起的感覺。
（根據角度不同可能有所差異。）

The larger the muscle, the more voluminous it is. (This may vary depending on the angle)

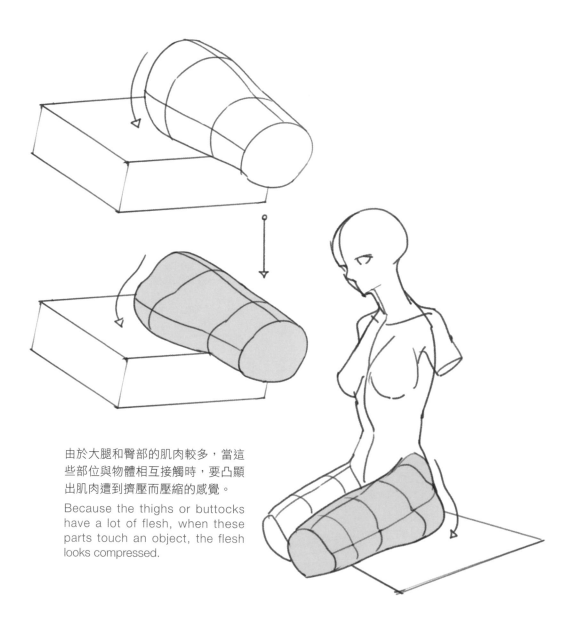

由於大腿和臀部的肌肉較多，當這些部位與物體相互接觸時，要凸顯出肌肉遭到擠壓而壓縮的感覺。

Because the thighs or buttocks have a lot of flesh, when these parts touch an object, the flesh looks compressed.

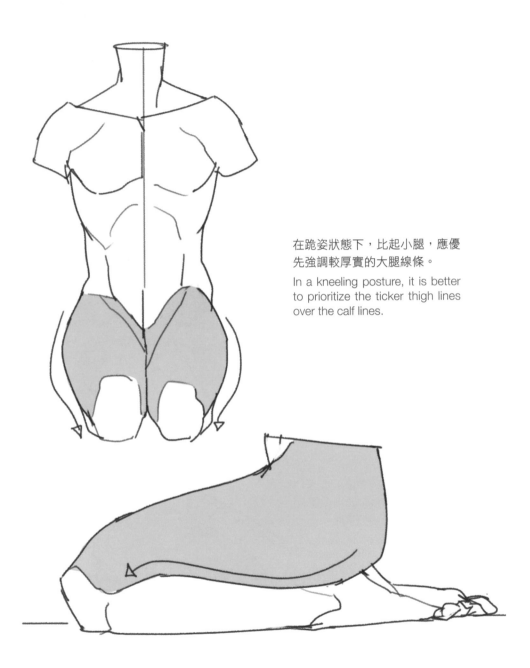

在跪姿狀態下，比起小腿，應優
先強調較厚實的大腿線條。

In a kneeling posture, it is better
to prioritize the ticker thigh lines
over the calf lines.

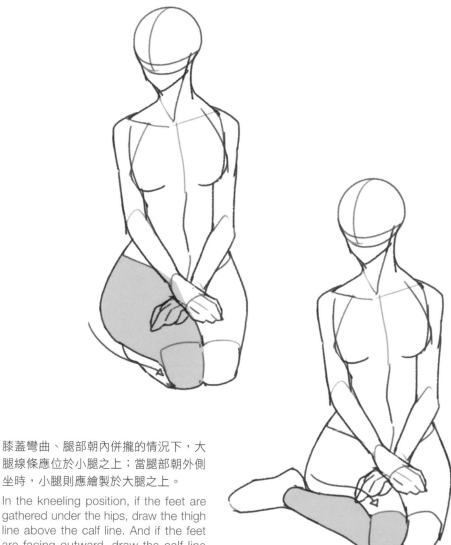

膝蓋彎曲、腿部朝內併攏的情況下，大腿線條應位於小腿之上；當腿部朝外側坐時，小腿則應繪製於大腿之上。

In the kneeling position, if the feet are gathered under the hips, draw the thigh line above the calf line. And if the feet are facing outward, draw the calf line above the thigh line.

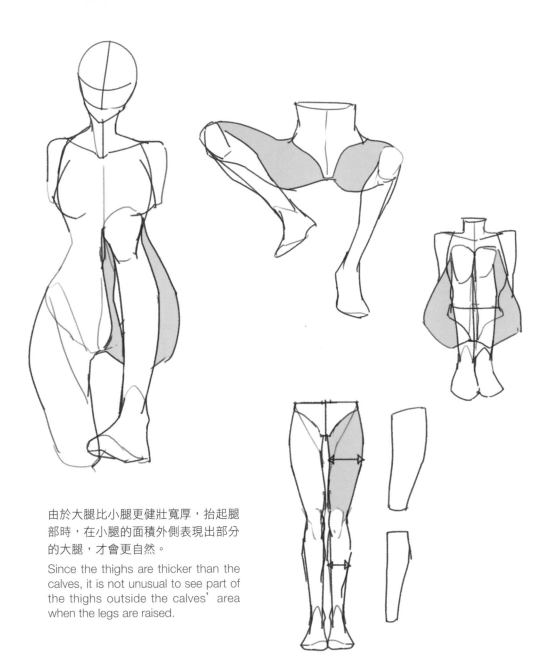

由於大腿比小腿更健壯寬厚，抬起腿部時，在小腿的面積外側表現出部分的大腿，才會更自然。

Since the thighs are thicker than the calves, it is not unusual to see part of the thighs outside the calves' area when the legs are raised.

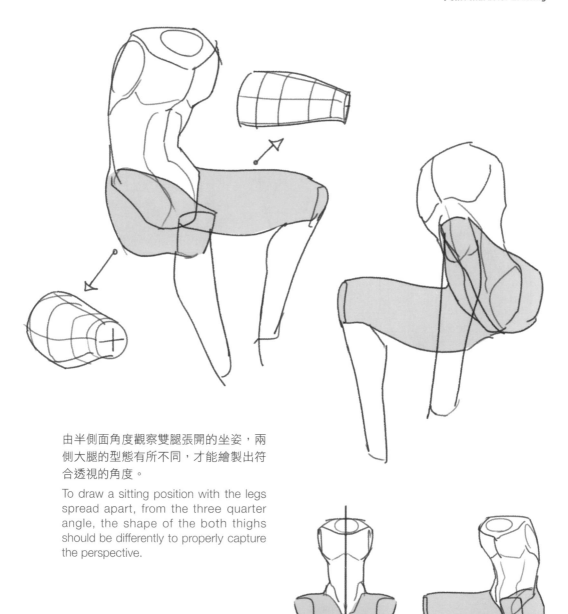

由半側面角度觀察雙腿張開的坐姿，兩側大腿的型態有所不同，才能繪製出符合透視的角度。

To draw a sitting position with the legs spread apart, from the three quarter angle, the shape of the both thighs should be differently to properly capture the perspective.

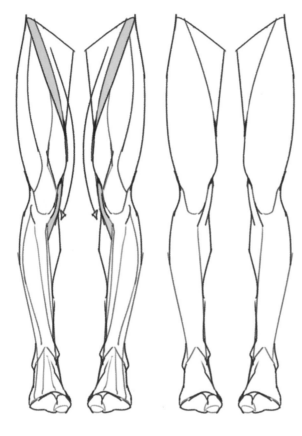

由於圖面中標示的肌肉（縫匠肌）
的緣故，從正面看，膝蓋內側會稍
微突出。

Due to the marked muscles, the
sartorius muscle, the knee at the
front is drawn with the inner part
protruding slightly.

由半側面或側面觀察時，可能
看不到突出的輪廓。

The corresponding silhouette
may not be visible from the
three quarter view or the side.

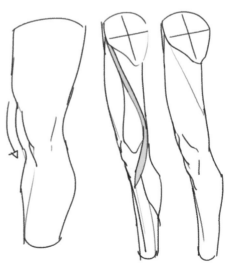

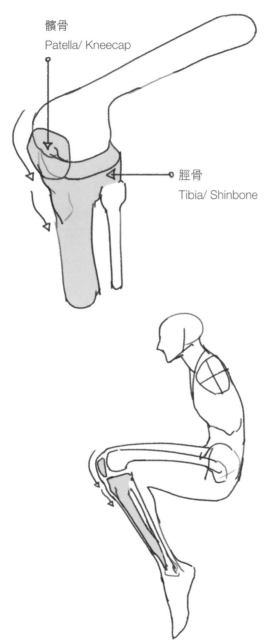

髕骨
Patella/ Kneecap

脛骨
Tibia/ Shinbone

膝蓋部位分為兩處小的隆起，這是分別因髕骨及脛骨而產生的輪廓。

The knee has two small silhouettes, which are caused by the patella and tibia.

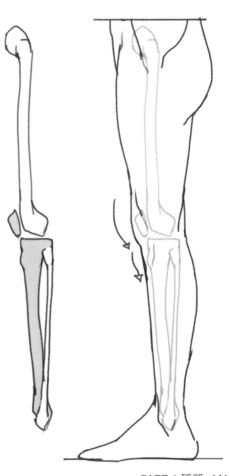

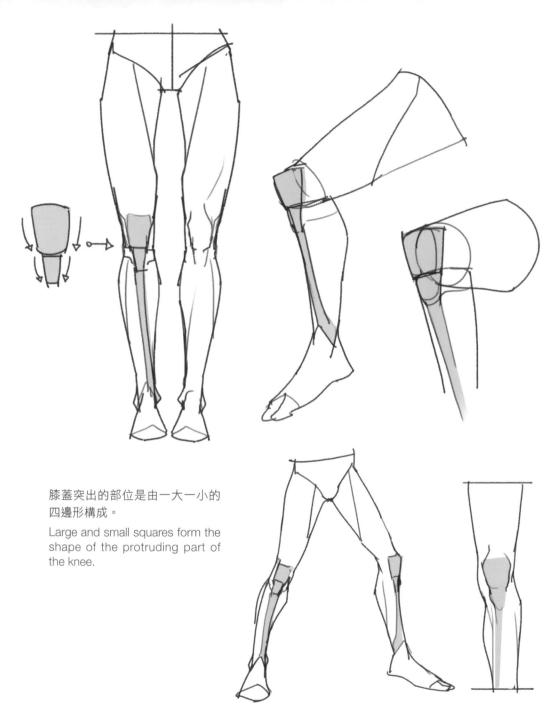

膝蓋突出的部位是由一大一小的
四邊形構成。

Large and small squares form the
shape of the protruding part of
the knee.

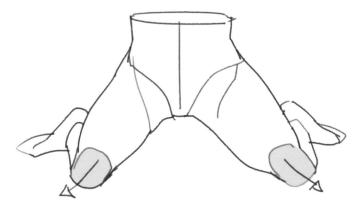

當腿部朝內、朝外或是垂直彎曲時，
膝蓋的方向也會隨之改變。

When the legs are folded inward
or outward, or bent vertically, the
direction of the knees also varies.

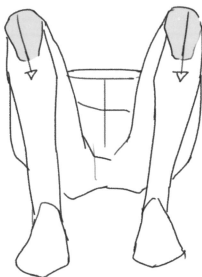

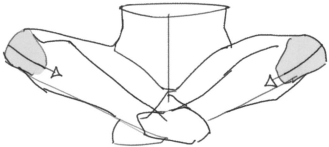

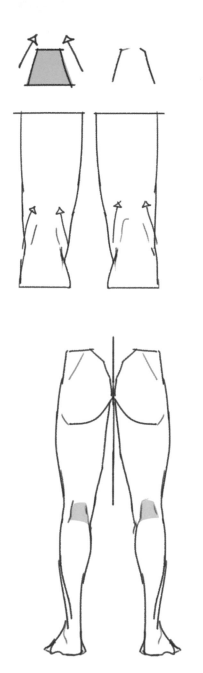

可將膝蓋的後側想像成一個梯形的
形狀，畫出向上收攏的線條。

For the back of the knees, draw
lines that gather upwards in a
trapezoidal shape.

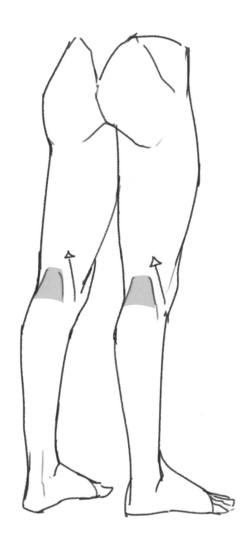

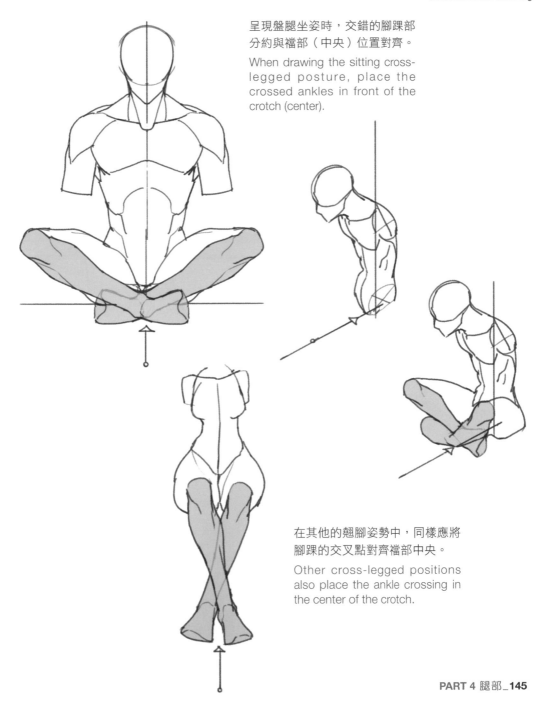

呈現盤腿坐姿時，交錯的腳踝部
分約與襠部（中央）位置對齊。

When drawing the sitting cross-legged posture, place the crossed ankles in front of the crotch (center).

在其他的翹腳姿勢中，同樣應將
腳踝的交叉點對齊襠部中央。

Other cross-legged positions also place the ankle crossing in the center of the crotch.

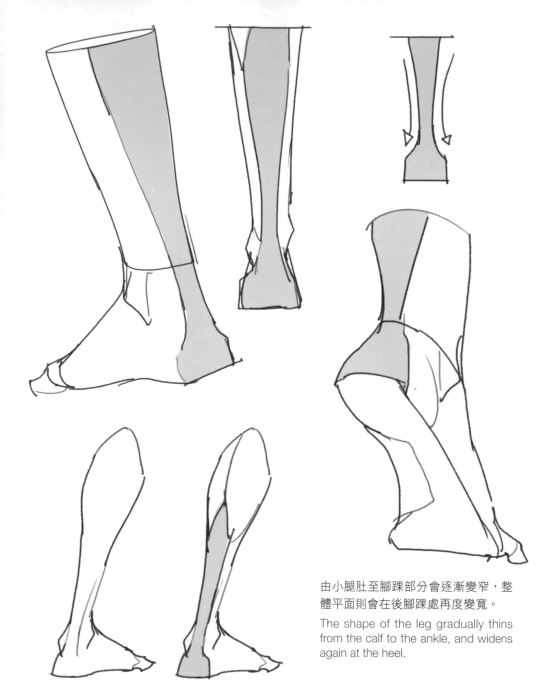

由小腿肚至腳踝部分會逐漸變窄，整體平面則會在後腳踝處再度變寬。

The shape of the leg gradually thins from the calf to the ankle, and widens again at the heel.

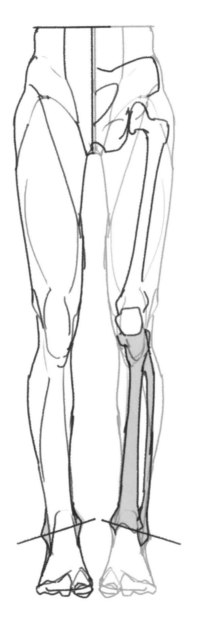

由於骨頭突出的緣故，靠近拇指處
的踝骨會略高小指一側。

The ankle bone protrudes higher
on the big toe side than the little
toe side.

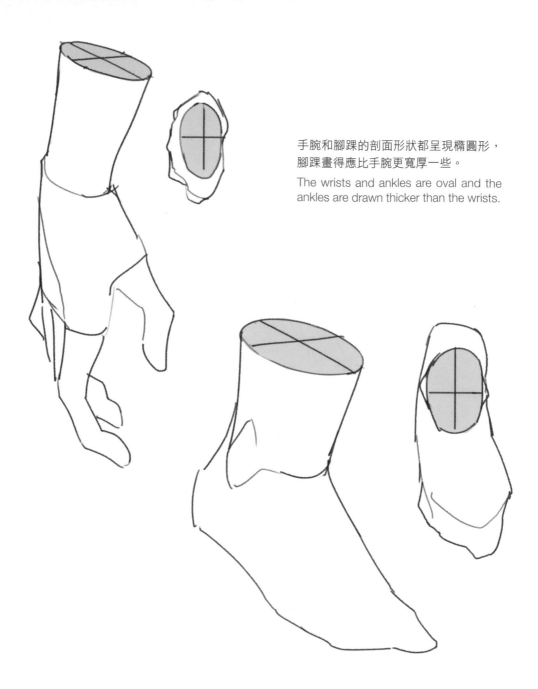

手腕和腳踝的剖面形狀都呈現橢圓形，
腳踝畫得應比手腕更寬厚一些。

The wrists and ankles are oval and the
ankles are drawn thicker than the wrists.

從側面觀察腳部時，由拇指尖端
至腳後跟處，大致是三個正方形
的寬度及高度。

When looking at the foot from
the side, the width and height
are about three squares from the
tip of the big toe to the heel.

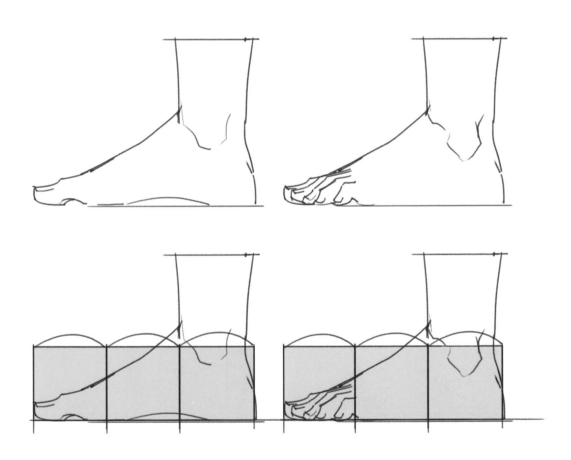

以踝骨正中央為基準，後方突出的
腳後跟長度，約與腳趾拇指的長度
相同。

the length of the big toe equals the
length from the center of the ankle
bone to the back of the heel.

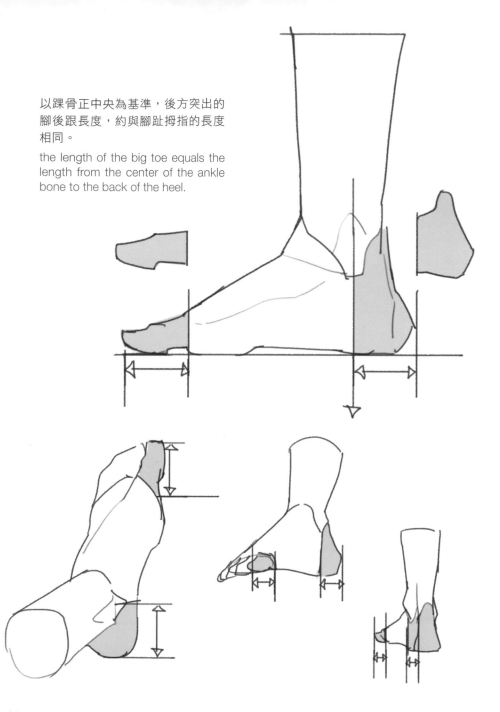

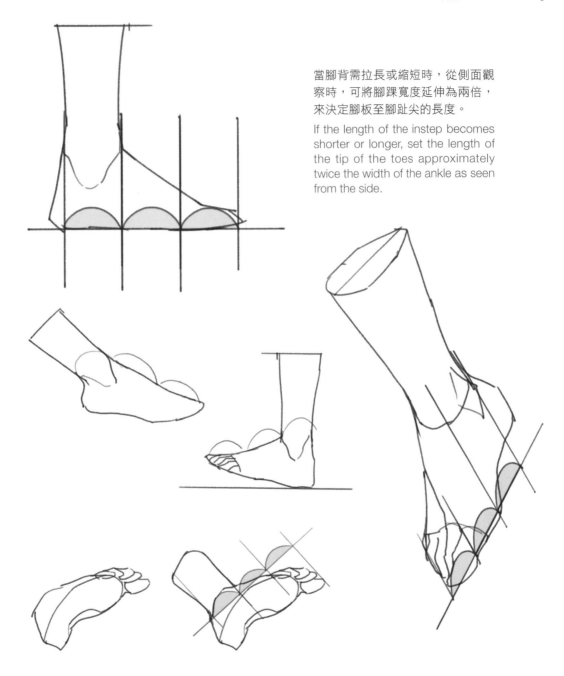

當腳背需拉長或縮短時，從側面觀察時，可將腳踝寬度延伸為兩倍，來決定腳板至腳趾尖的長度。

If the length of the instep becomes shorter or longer, set the length of the tip of the toes approximately twice the width of the ankle as seen from the side.

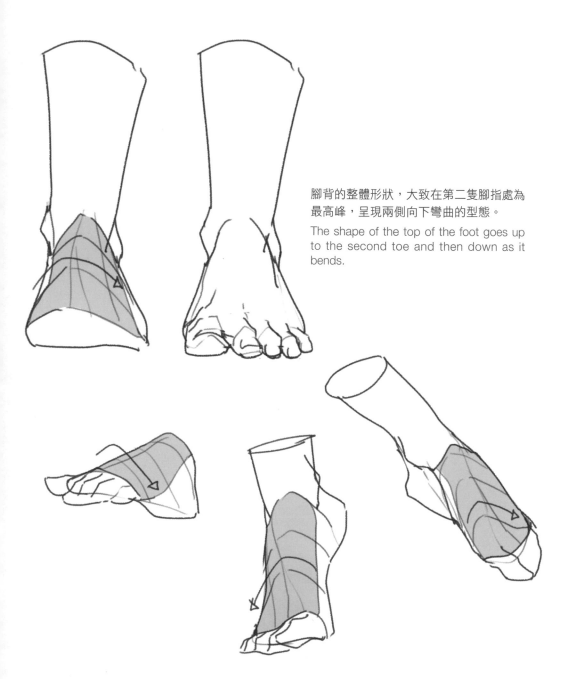

腳背的整體形狀，大致在第二隻腳指處為最高峰，呈現兩側向下彎曲的型態。

The shape of the top of the foot goes up to the second toe and then down as it bends.

由半側面角度觀察時，以拇指為基準，由腳踝連接至拇指處的斜線，會在腳背上形成一個三角形的平面。

At the three quarter angle facing the big toe, a triangle shape is made on the top of the foot with a diagonal line from the ankle to the big toe.

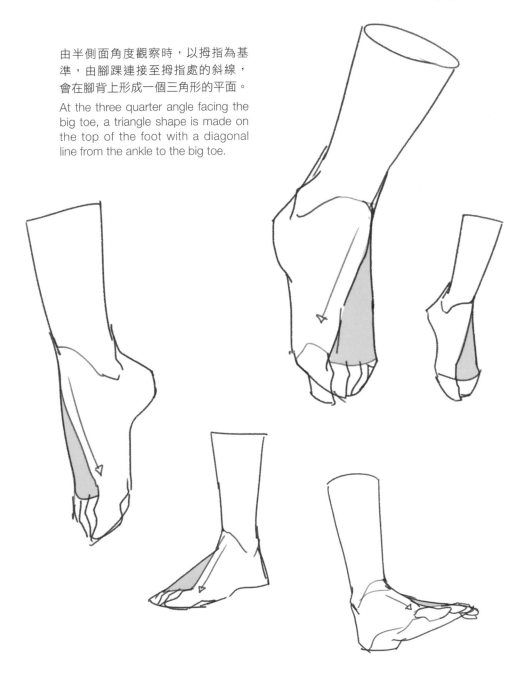

繪製走動中的正面人物時，應將後側的
腳部位置提高，將腳背畫出來。

When drawing the front of a walking
character, raise the height of the foot in
the back and draw the top of the foot.

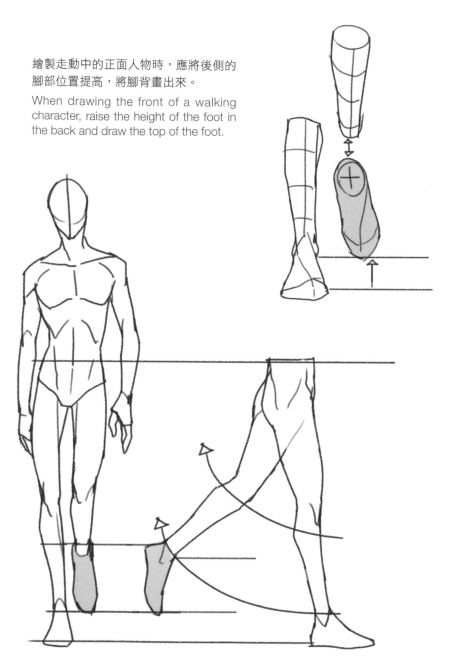

拇指處的腳掌內側線條應稍微
向內凹陷。

Draw the inner line of the sole
on the side of the big toe slightly
inward.

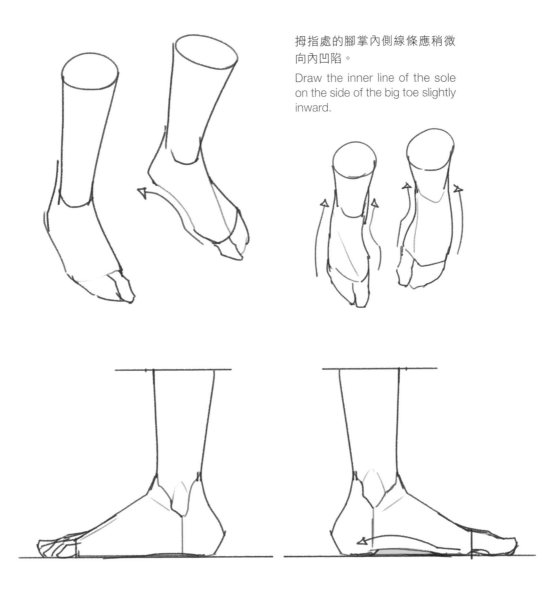

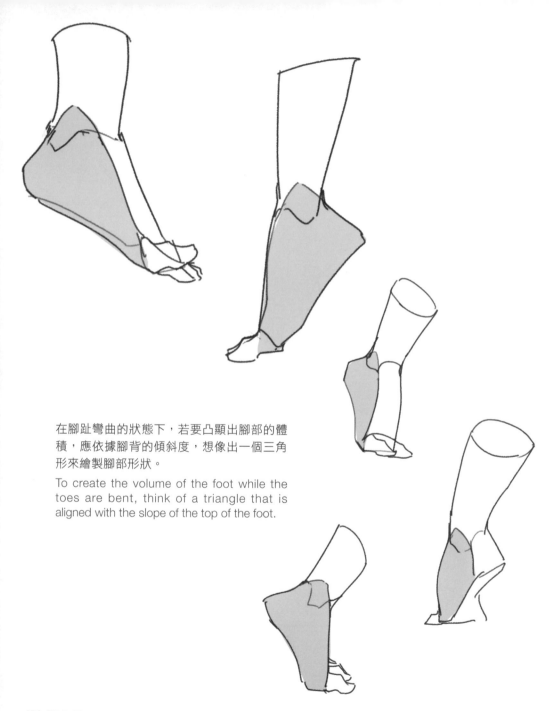

在腳趾彎曲的狀態下，若要凸顯出腳部的體
積，應依據腳背的傾斜度，想像出一個三角
形來繪製腳部形狀。

To create the volume of the foot while the
toes are bent, think of a triangle that is
aligned with the slope of the top of the foot.

腳尖至腳跟連接起來的傾斜度即為地面的
角度。

The slope of the tip of the toe and the heel
indicates the angle of the ground.

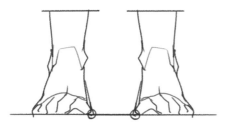

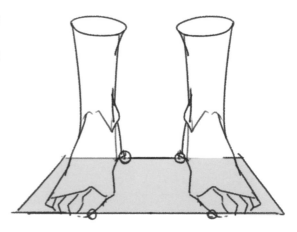

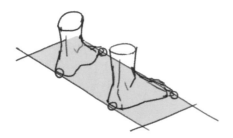

踮腳、抬高腳跟時，必須要從地面的角度
出發，形塑出腳趾和腳跟處的高度差異。

When raising the heel, the difference in
height between the toes and the heels
should correspond to the desired slope of
the floor.

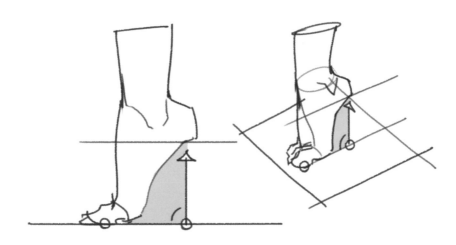

由正面觀察時，能看見小部分的後腳跟，仔細繪製出來會更具立體感。

As for the feet seen from the front, make the heels visible to create a three-dimensional effect.

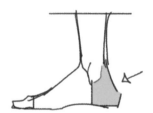

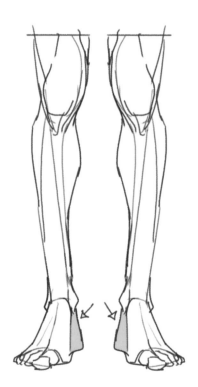

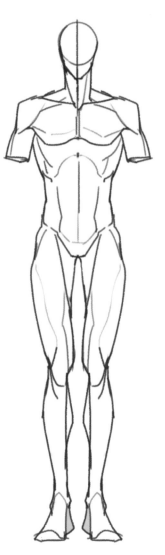

由後方觀察半側面時，雙腳的型態略有不同，較接近畫面的那隻腳應多展現出腳的側面，透視感更佳。

At the three quarter rear view, the shape of both feet is drawn differently. And it is good for perspective to show more of the side of the foot closer to the screen.

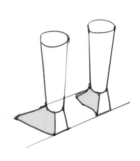

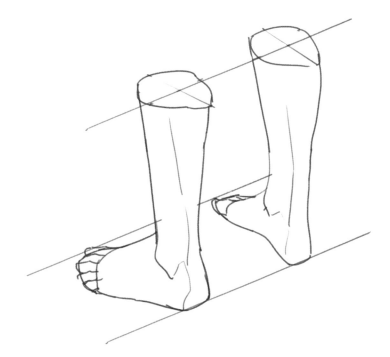

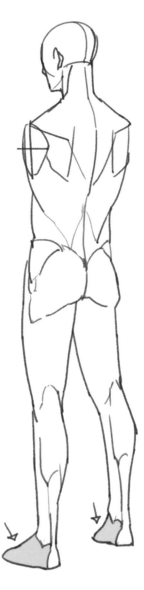

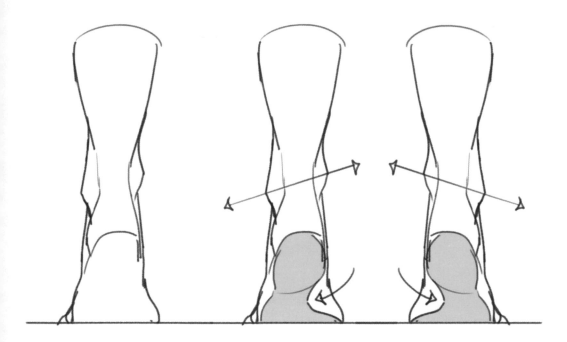

由正後方觀察，抬起後腳跟的情況，由於兩側的輪廓並無太大差異，所以須由踝骨的位置及腳底的形狀的表現來區分。

When viewed from the back, there is no significant difference between the silhouettes of both feet when the heels are raised. Thus, the difference is indicated by the position of the ankle bone and the expression of the sole of the foot.

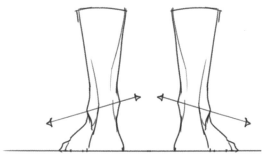

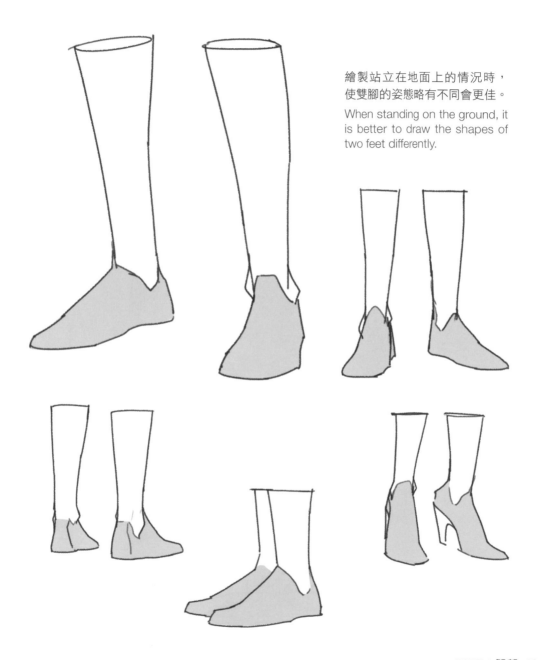

繪製站立在地面上的情況時，
使雙腳的姿態略有不同會更佳。

When standing on the ground, it
is better to draw the shapes of
two feet differently.

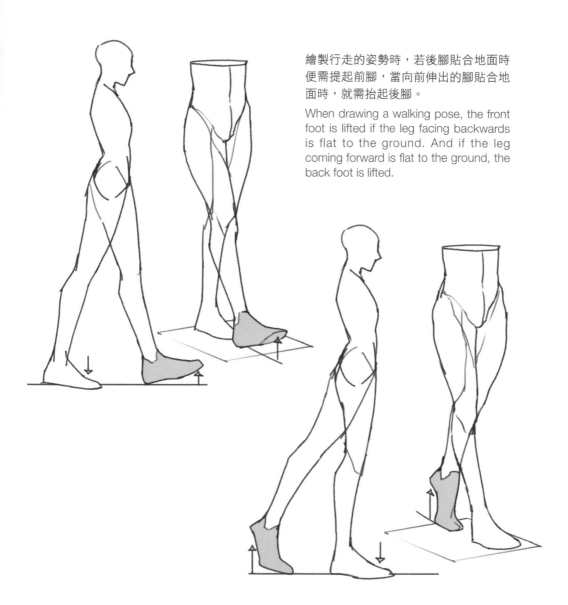

繪製行走的姿勢時，若後腳貼合地面時便需提起前腳，當向前伸出的腳貼合地面時，就需抬起後腳。

When drawing a walking pose, the front foot is lifted if the leg facing backwards is flat to the ground. And if the leg coming forward is flat to the ground, the back foot is lifted.

當腳跟抬得愈高，腳背前側的傾斜度就會愈接近垂直，後腳跟也顯得更突出。

The more the heel is lifted, the closer the slope of the top of the foot and the front of the ankle is to the vertical, and the more the heel protrudes.

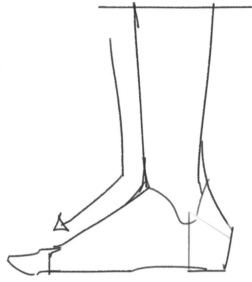

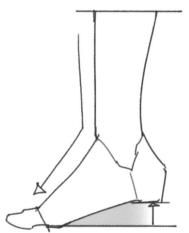

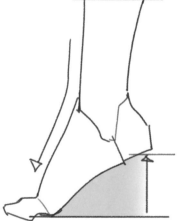

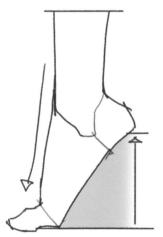

呈跪姿狀態時，根據大腿的角度
不同，腳部接觸地面的動作也會
有所不同。

When kneeling down, the shape
of the part of the foot that
touches the ground depends on
the angle of the thighs.

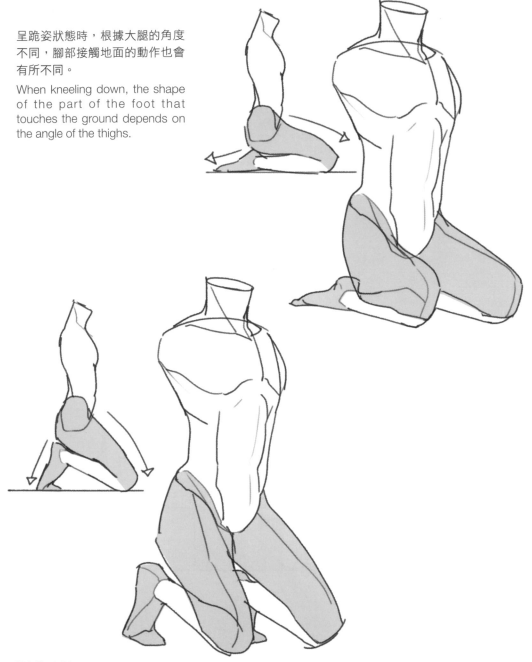

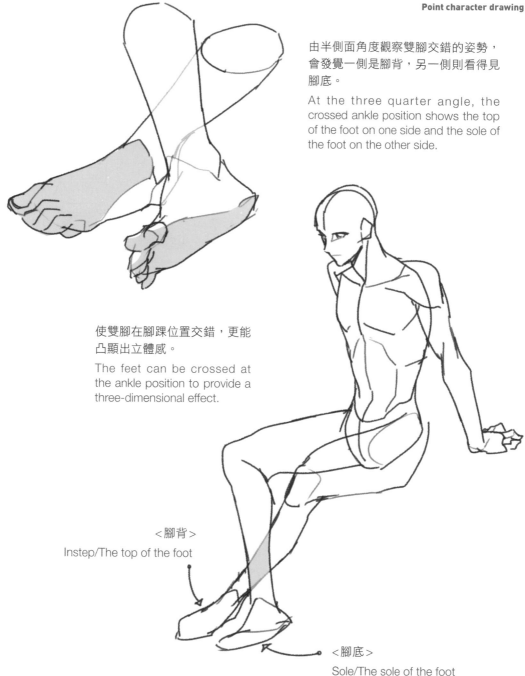

由半側面角度觀察雙腳交錯的姿勢，
會發覺一側是腳背，另一側則看得見
腳底。

At the three quarter angle, the
crossed ankle position shows the top
of the foot on one side and the sole of
the foot on the other side.

使雙腳在腳踝位置交錯，更能
凸顯出立體感。

The feet can be crossed at
the ankle position to provide a
three-dimensional effect.

<腳背>
Instep/The top of the foot

<腳底>
Sole/The sole of the foot

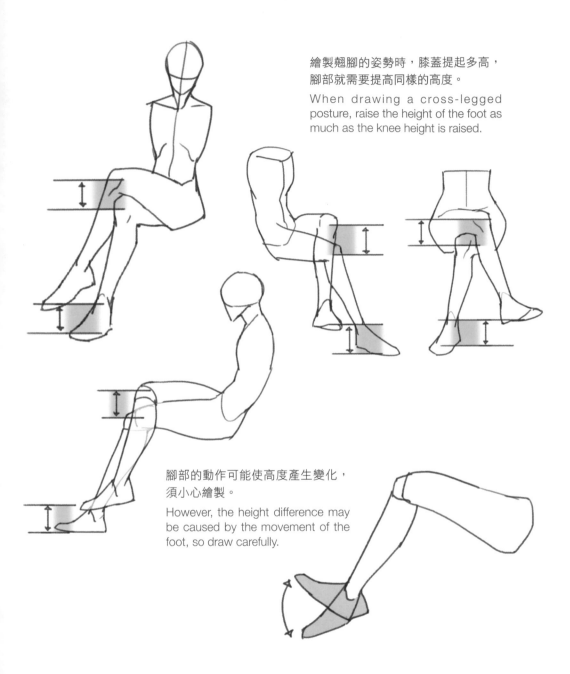

繪製翹腳的姿勢時，膝蓋提起多高，腳部就需要提高同樣的高度。

When drawing a cross-legged posture, raise the height of the foot as much as the knee height is raised.

腳部的動作可能使高度產生變化，須小心繪製。

However, the height difference may be caused by the movement of the foot, so draw carefully.

若稍稍抬起腳的尖端部分，使腳底部分顯現出來，腳的型態會更好看。

Drawing the front part of the foot so that it is slightly raised, with the bottom visible, will make the shape of the foot pretty.

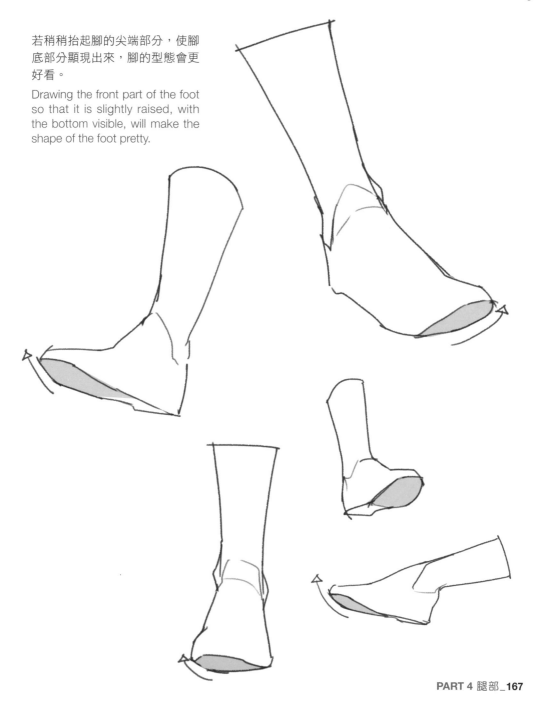

繪製可看見腳底的角度時，使腳踝
透視的平面與腳底角度保持一致，
會更容易繪製。

When drawing feet with visible soles,
align the angle of the ankle with that
of the sole.

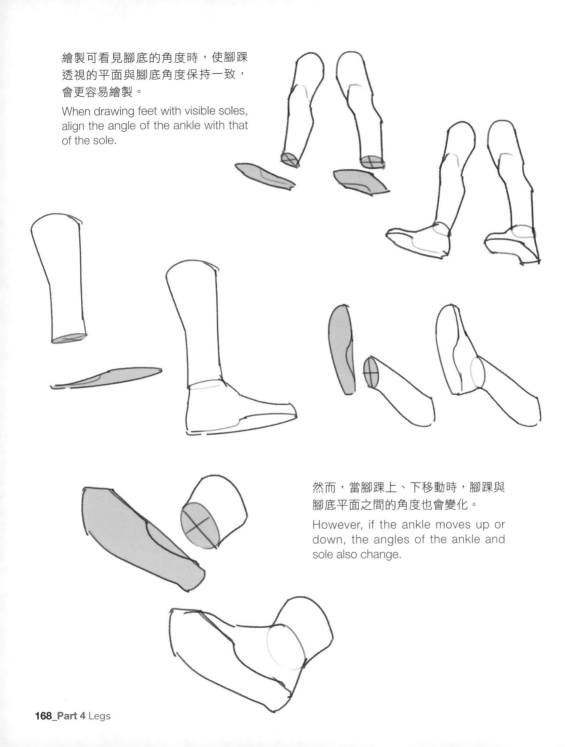

然而，當腳踝上、下移動時，腳踝與
腳底平面之間的角度也會變化。

However, if the ankle moves up or
down, the angles of the ankle and
sole also change.

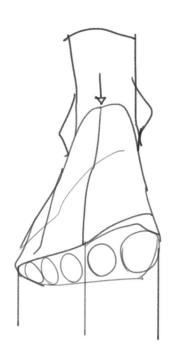
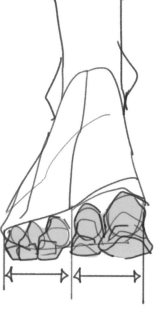
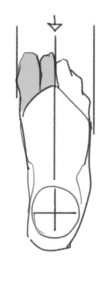

繪製腳部時，以腳背中心線為基準，
將拇指、食指和剩餘三指以 1：1 的比
例區分開來，會更容易表現腳的體積。

When drawing a foot, it is easy to gauge
the correct volume by dividing the big
toe and index toe, and the other three
toes in a one-to-one ratio based on the
center line of the top of the foot.

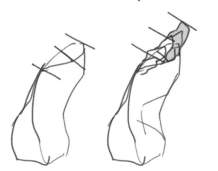

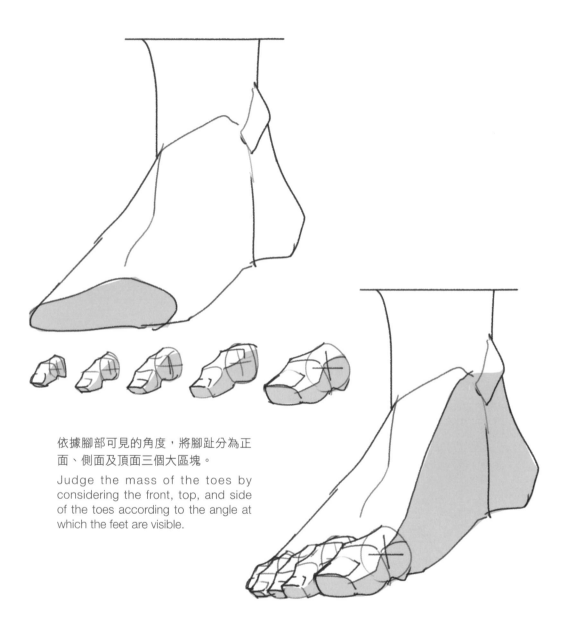

依據腳部可見的角度，將腳趾分為正面、側面及頂面三個大區塊。

Judge the mass of the toes by considering the front, top, and side of the toes according to the angle at which the feet are visible.

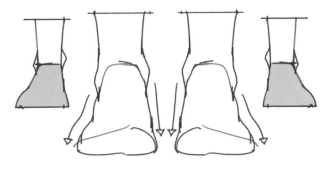

由正面角度繪製腳部時，比起大拇指所在的內側，小指所在的外側傾斜度更大一些。

When drawing the foot from the front, draw the outer part with the little toe slightly more inclined than the inner part with the big toe.

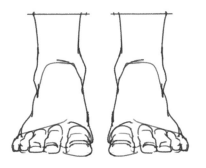 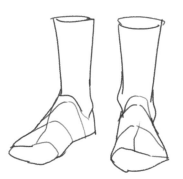

由背面觀察時，若沒有特殊的角度，就適用相同的原則。

When viewed from the back, the same applies assuming the feet are facing straight.

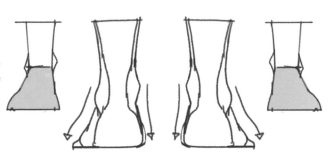

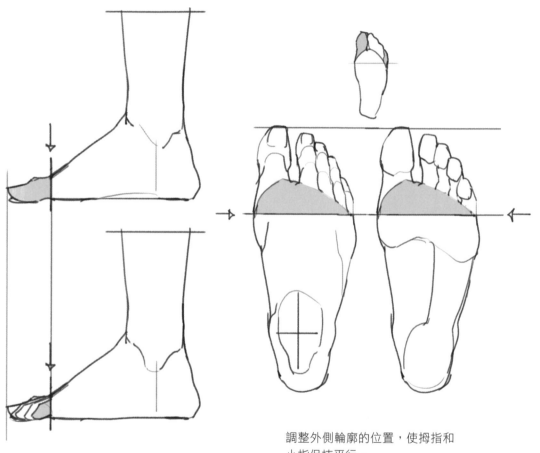

調整外側輪廓的位置，使拇指和
小指保持平行。

Horizontally adjust the position of
the outer silhouette where the big
toe and little toe come out.

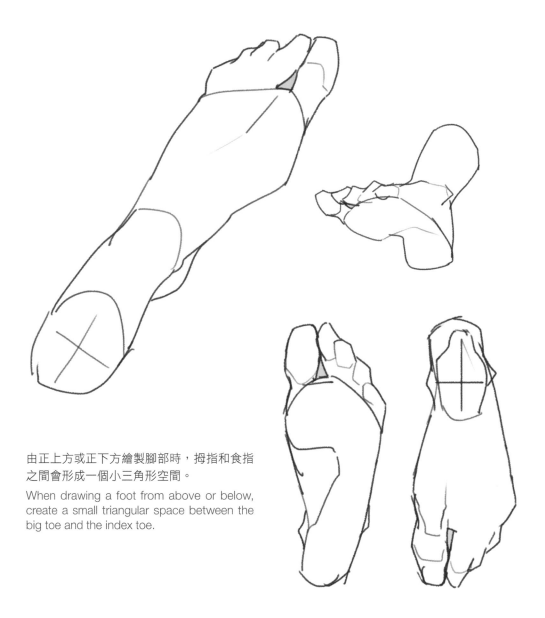

由正上方或正下方繪製腳部時，拇指和食指之間會形成一個小三角形空間。

When drawing a foot from above or below, create a small triangular space between the big toe and the index toe.

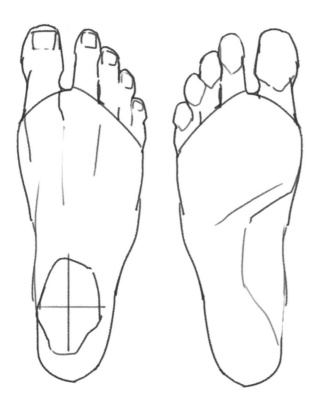

由正上方或正下方觀察腳部，腳趾尖端繪製成稍微突出的型態即可。

The shape of the foot seen from above or below is drawn with the tips of the toes slightly protruding.

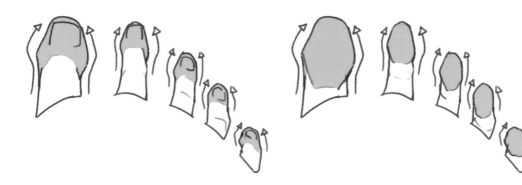

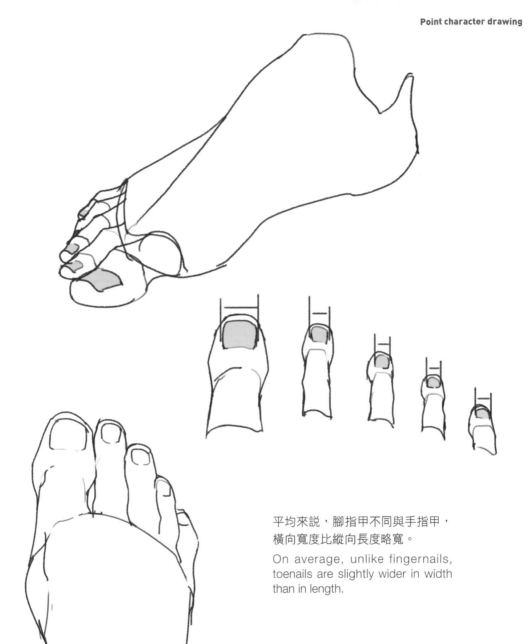

平均來説，腳指甲不同與手指甲，
橫向寬度比縱向長度略寬。

On average, unlike fingernails,
toenails are slightly wider in width
than in length.

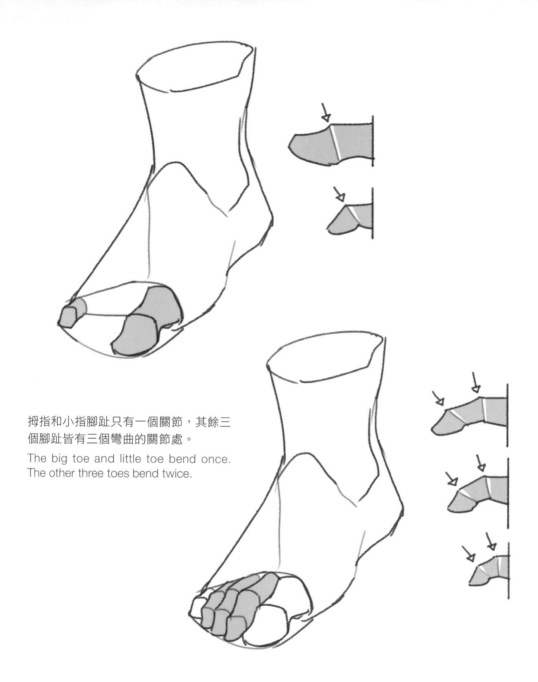

拇指和小指腳趾只有一個關節，其餘三個腳趾皆有三個彎曲的關節處。

The big toe and little toe bend once.
The other three toes bend twice.

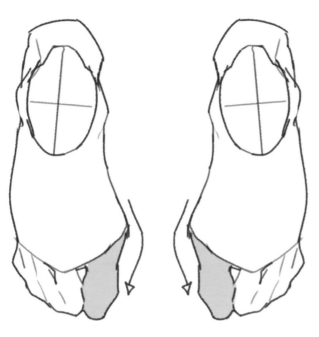

表現拇指腳趾時，會稍微朝內彎曲。

Express the big toe by bending it slightly inward.

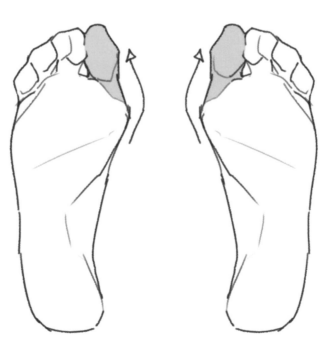

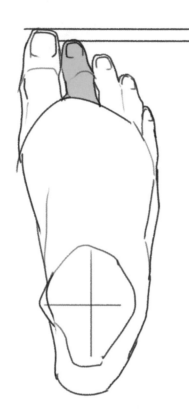

第二隻腳指的長度每個人皆略有不同。

The length of the second toe varies depending on the person.

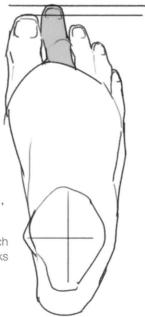

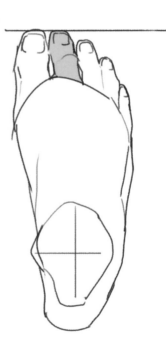

由拇指腳趾開始，腳指平緩地縮短，看起來最為美觀。

For some, reducing the length of each toe sequentially from the big toe looks best.

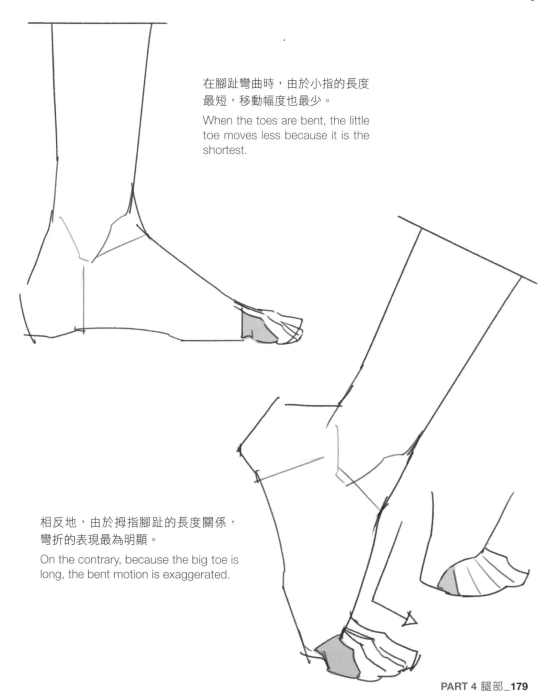

在腳趾彎曲時，由於小指的長度
最短，移動幅度也最少。

When the toes are bent, the little
toe moves less because it is the
shortest.

相反地，由於拇指腳趾的長度關係，
彎折的表現最為明顯。

On the contrary, because the big toe is
long, the bent motion is exaggerated.

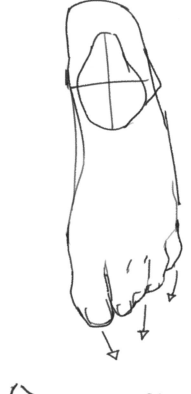

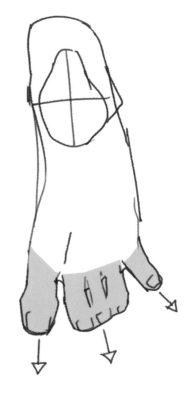

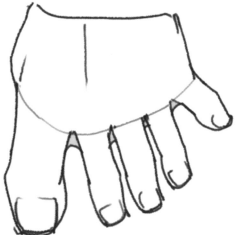

若腳趾朝兩側展開，拇指會朝向正前方，小指看起來是朝外伸展，中央的三隻腳趾則不太能伸展。

When the toes are spread out on both sides, the big toe faces forward and the little toe faces outward. The middle three toes do not spread far.

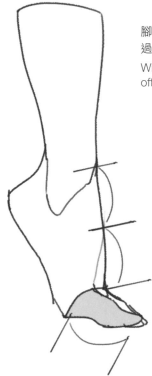

腳趾彎曲時，時常會不小心畫得
過長或過短。

When the toes are bent, they are
often drawn short or long.

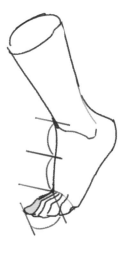

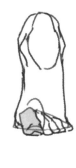

拇指彎曲起來的長度，約莫可視為腳背
長度的二分之一左右。

The length of the bent big toe is
approximately one-half the length of the
instep.

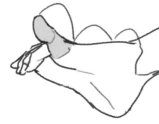

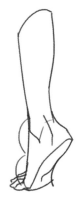

不過，從正面或背面觀察時，須考
慮到透視效果來決定長度。

However, if the foot is viewed from
the front or from the back, the
length of the big toe should be
drawn to reflect the perspective.

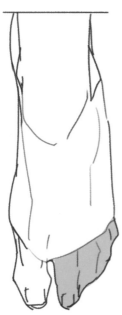

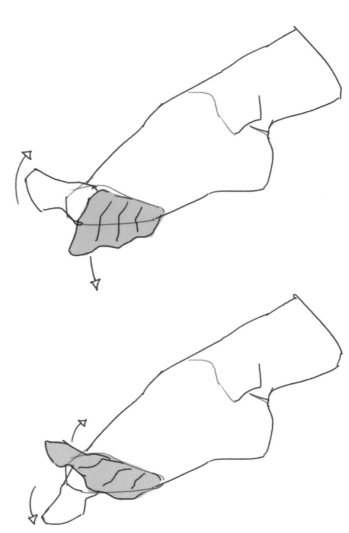

腳趾的移動和手指不同，會形成一個整體一起移動。

When drawing moving toes, unlike fingers, they are bound together in a single mass to create movement.

將腳趾尖端彎曲起來繪製陰影會
較為單純。

To simplify drawing toes, bend
and shade their tips.

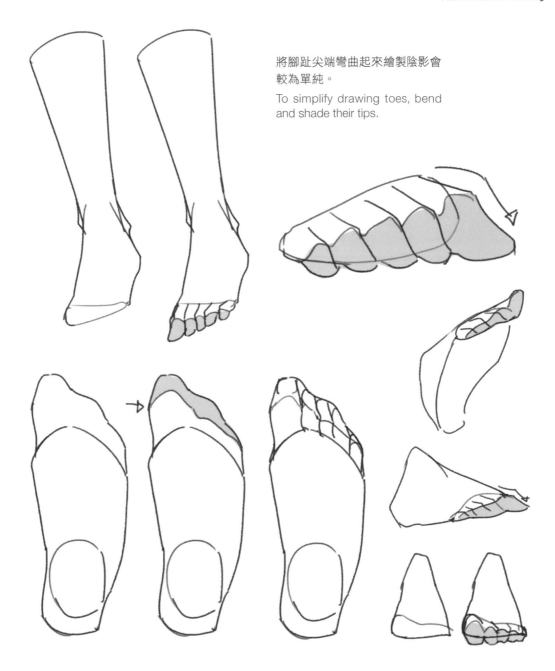

在能夠看見腳底的情況，想像腳掌接觸地面的模樣，就能輕鬆掌握好形狀。

When the soles of the feet are visible, outline the area and shape of the part of the foot that touches the floor.

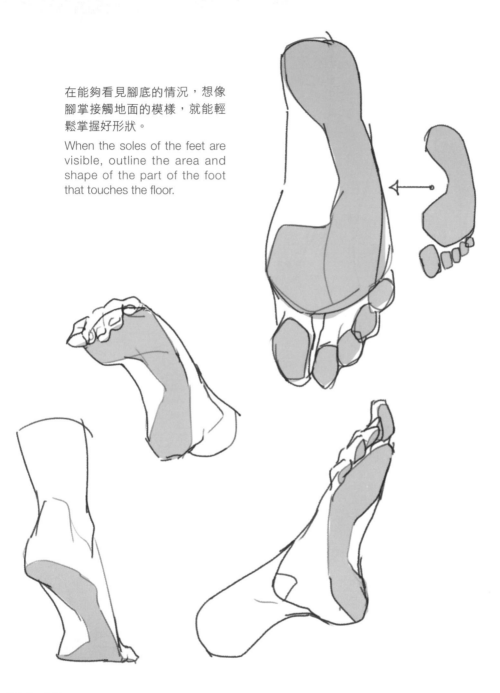

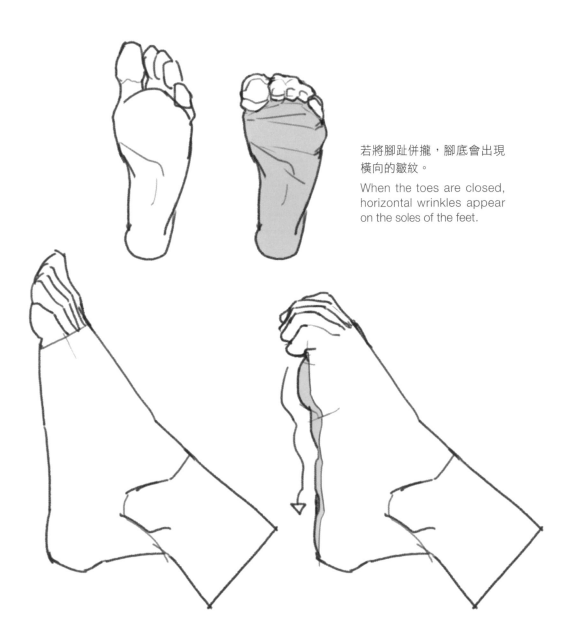

若將腳趾併攏，腳底會出現橫向的皺紋。

When the toes are closed, horizontal wrinkles appear on the soles of the feet.

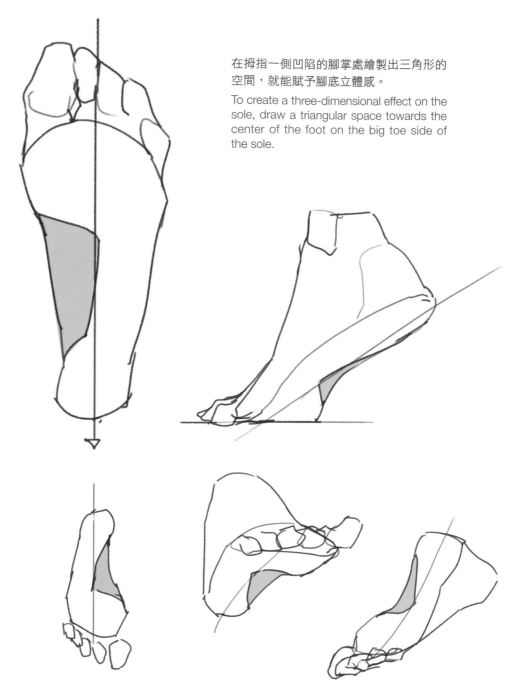

在拇指一側凹陷的腳掌處繪製出三角形的
空間，就能賦予腳底立體感。

To create a three-dimensional effect on the
sole, draw a triangular space towards the
center of the foot on the big toe side of
the sole.

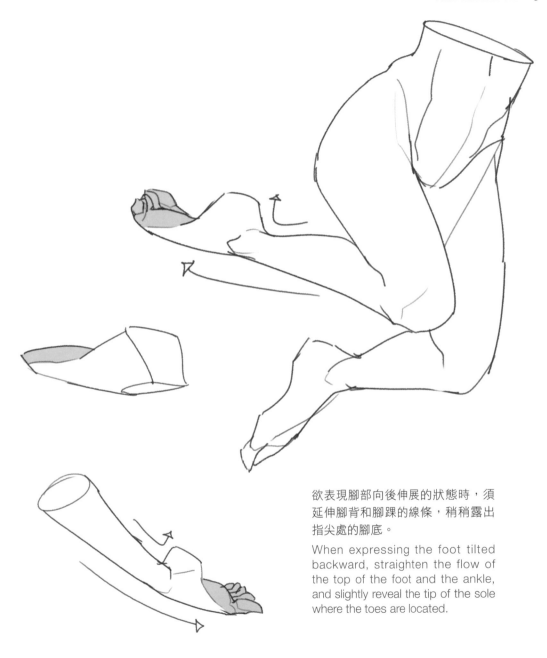

欲表現腳部向後伸展的狀態時,須
延伸腳背和腳踝的線條,稍稍露出
指尖處的腳底。

When expressing the foot tilted
backward, straighten the flow of
the top of the foot and the ankle,
and slightly reveal the tip of the sole
where the toes are located.

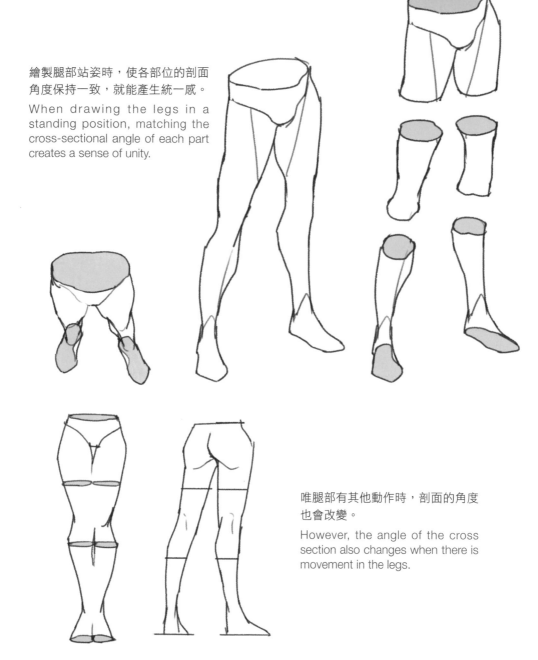

繪製腿部站姿時，使各部位的剖面
角度保持一致，就能產生統一感。

When drawing the legs in a
standing position, matching the
cross-sectional angle of each part
creates a sense of unity.

唯腿部有其他動作時，剖面的角度
也會改變。

However, the angle of the cross
section also changes when there is
movement in the legs.

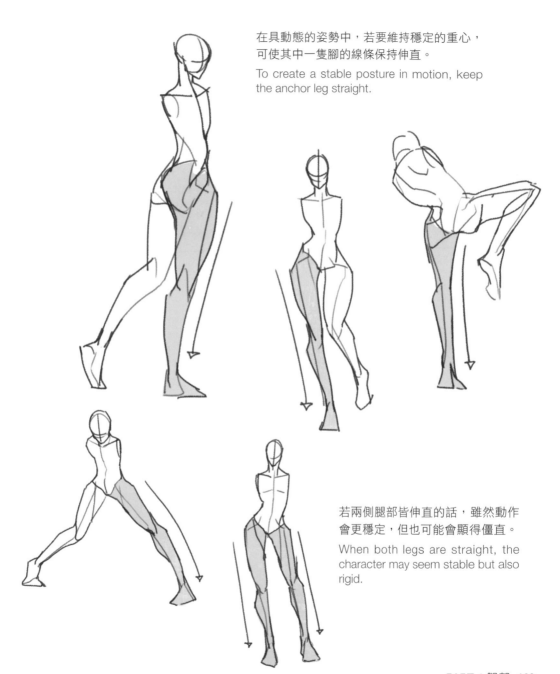

在具動態的姿勢中，若要維持穩定的重心，
可使其中一隻腳的線條保持伸直。

To create a stable posture in motion, keep
the anchor leg straight.

若兩側腿部皆伸直的話，雖然動作
會更穩定，但也可能會顯得僵直。

When both legs are straight, the
character may seem stable but also
rigid.

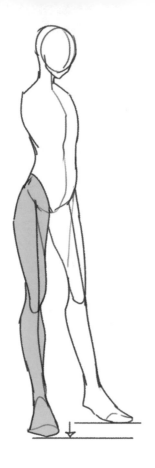
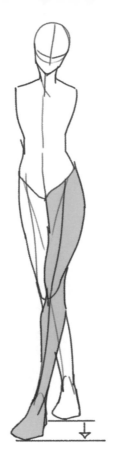
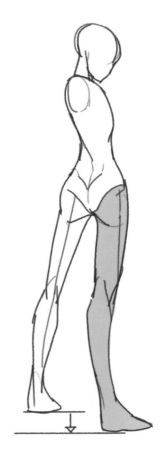

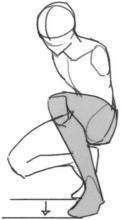

踩著地面形成站姿時，調整靠近畫面的腳部，使位置稍微向下，就能形成自然的透視感。

In a standing position on the ground, a natural perspective is created by setting the position of the foot which is closer to the screen slightly lower than the other foot.

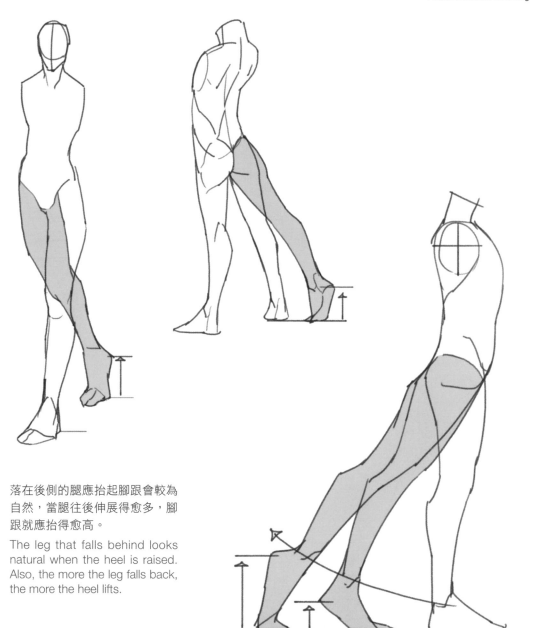

落在後側的腿應抬起腳跟會較為
自然，當腿往後伸展得愈多，腳
跟就應抬得愈高。

The leg that falls behind looks
natural when the heel is raised.
Also, the more the leg falls back,
the more the heel lifts.

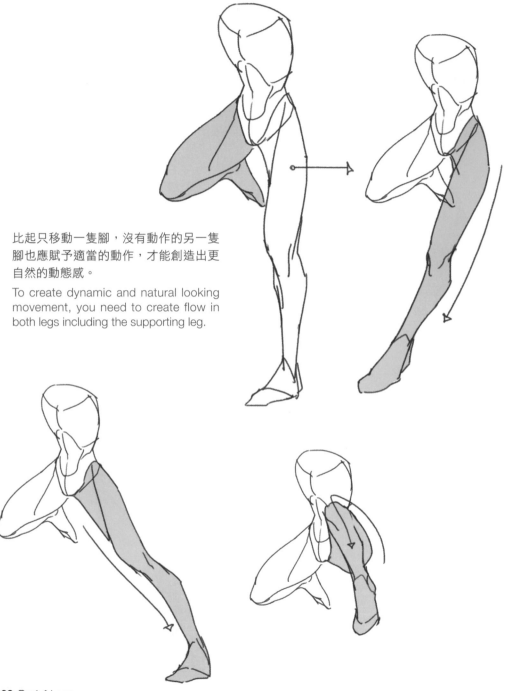

比起只移動一隻腳，沒有動作的另一隻
腳也應賦予適當的動作，才能創造出更
自然的動態感。

To create dynamic and natural looking
movement, you need to create flow in
both legs including the supporting leg.

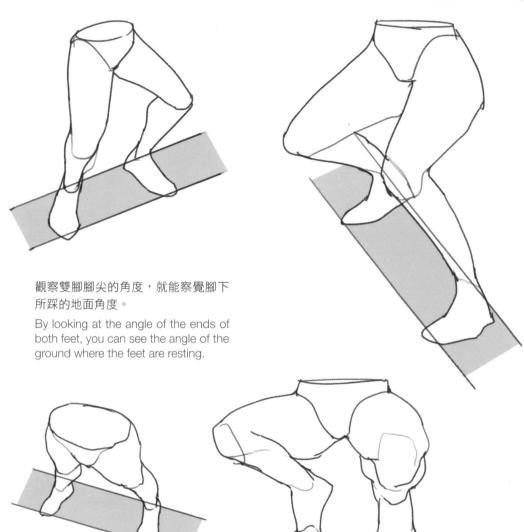

觀察雙腳腳尖的角度，就能察覺腳下所踩的地面角度。

By looking at the angle of the ends of both feet, you can see the angle of the ground where the feet are resting.

當然，若腳和地面有一段距離，亦有可能難以觀察。

Of course, if the foot is off the ground, this changes.

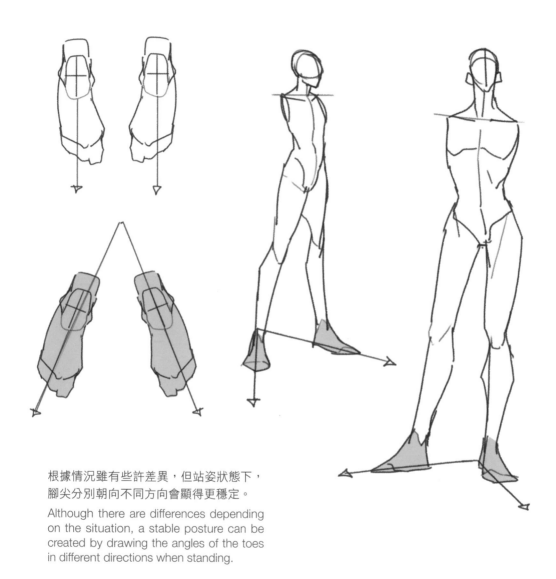

根據情況雖有些許差異，但站姿狀態下，
腳尖分別朝向不同方向會顯得更穩定。

Although there are differences depending
on the situation, a stable posture can be
created by drawing the angles of the toes
in different directions when standing.

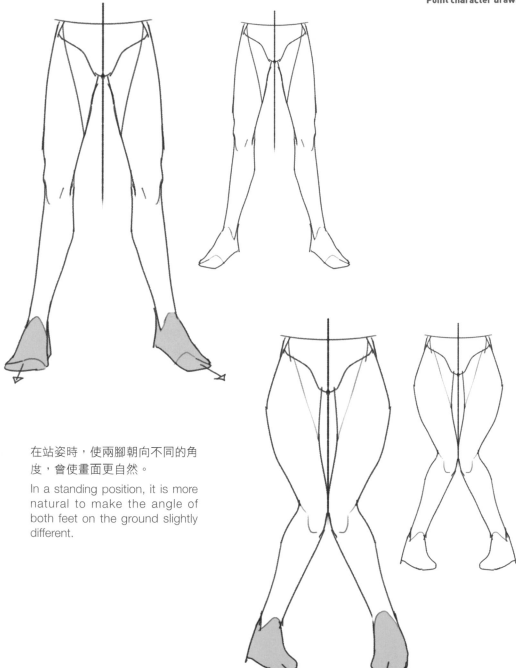

在站姿時，使兩腳朝向不同的角度，會使畫面更自然。

In a standing position, it is more natural to make the angle of both feet on the ground slightly different.

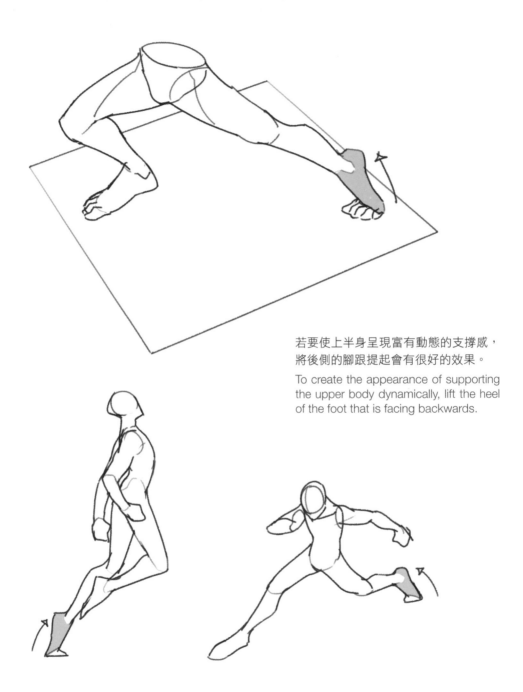

若要使上半身呈現富有動態的支撐感，
將後側的腳跟提起會有很好的效果。

To create the appearance of supporting
the upper body dynamically, lift the heel
of the foot that is facing backwards.

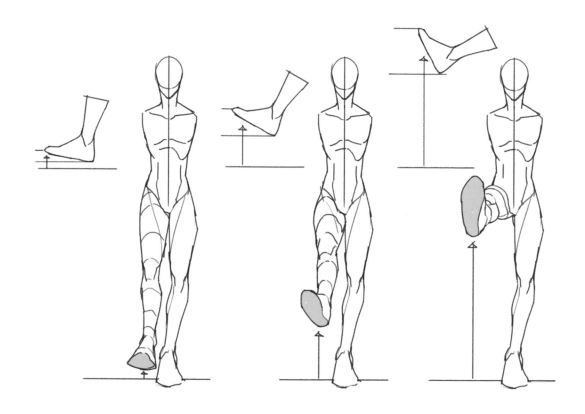

在抬起腿部、顯露出腳底的情況下，腿部距離地面愈遠，腳底露出的面積愈大。

When raising the legs to make the soles of the feet visible, the further the distance between the ground and the legs, the more the soles of the feet are visible.

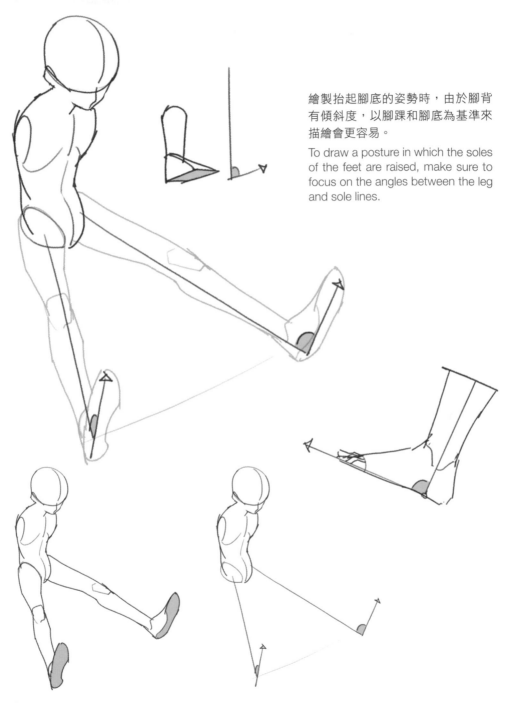

繪製抬起腳底的姿勢時，由於腳背有傾斜度，以腳踝和腳底為基準來描繪會更容易。

To draw a posture in which the soles of the feet are raised, make sure to focus on the angles between the leg and sole lines.

若下壓腳踝，使小腿和腳背平行，很適合表現漂浮在空中或具有速度感的姿勢。

In order to create the appearance of the foot floating in the air or in motion, make the angle between the shin and the instep vertical by bending the ankle.

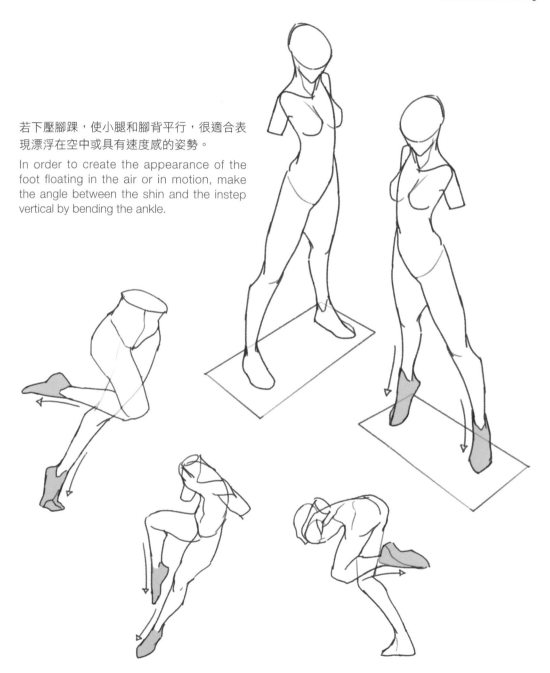

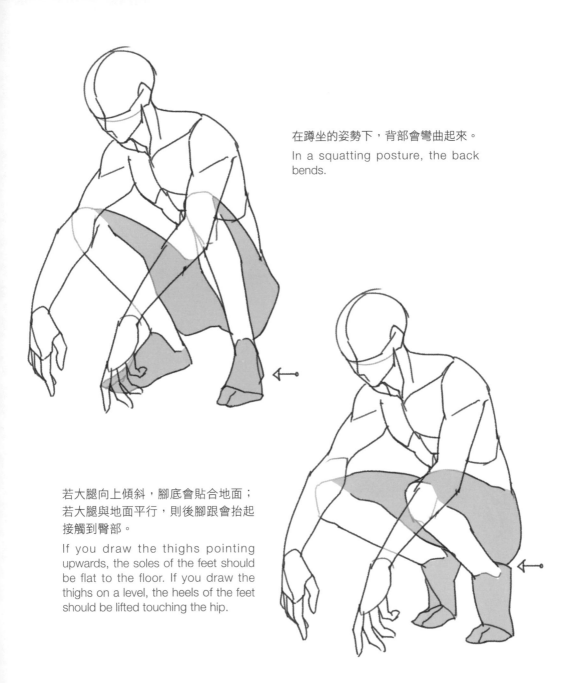

在蹲坐的姿勢下，背部會彎曲起來。

In a squatting posture, the back bends.

若大腿向上傾斜，腳底會貼合地面；若大腿與地面平行，則後腳跟會抬起接觸到臀部。

If you draw the thighs pointing upwards, the soles of the feet should be flat to the floor. If you draw the thighs on a level, the heels of the feet should be lifted touching the hip.

漂浮在空中的狀態下，使兩腿動作不同、
有高低差異，會顯得更自然。

When the body is floating in the air, it looks
natural if the flow and height of both legs
are different.

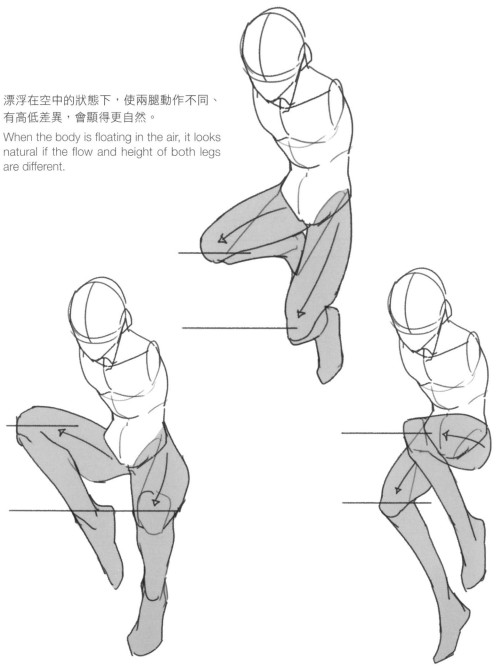

韓國繪師的角色繪製重點攻略

# Part 5 示範圖集

illustrations:
face/body drawing reference guide

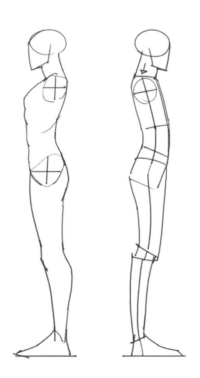

臉部正面，左／右半側面

Face front, three quarter three quarter 3/4 view, left/right

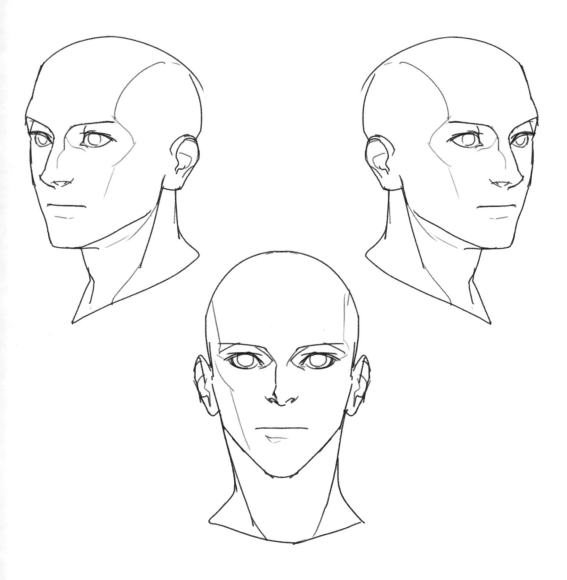

臉部左／右側面

Face side, left/right

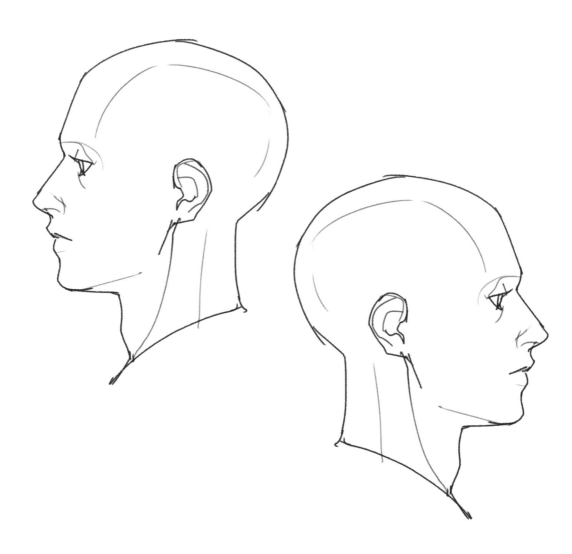

臉部背面，左／右半側面

Face back, 3/4 view, left/right

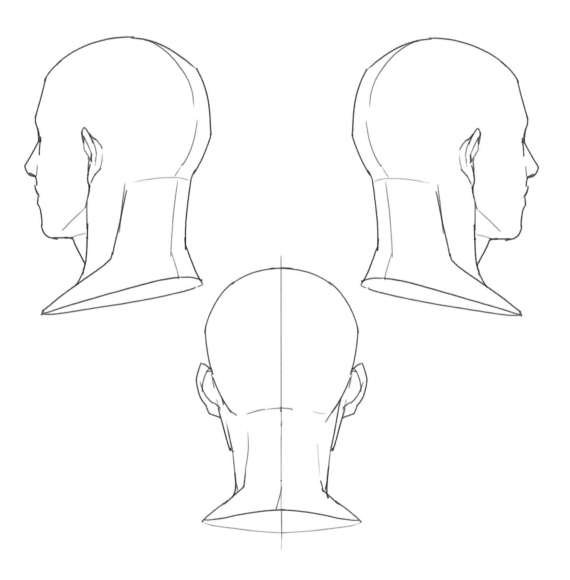

臉部正面高視角
Face front, high angle

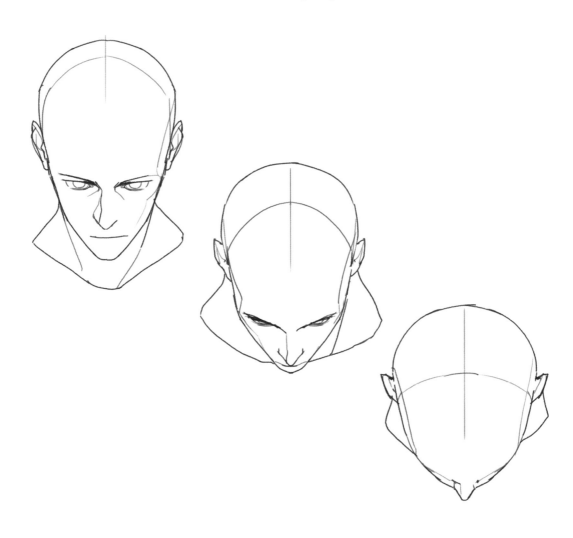

臉部左／右半側面高視角

Face 3/4 view, high angle, left/right

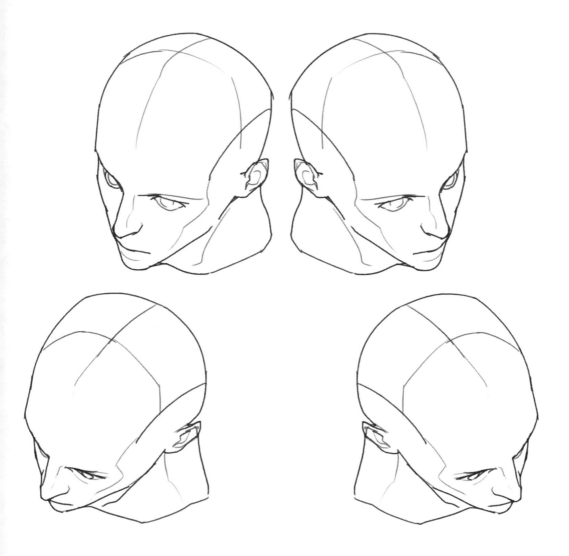

臉部左／右側面高視角
Face side, high angle, left/right

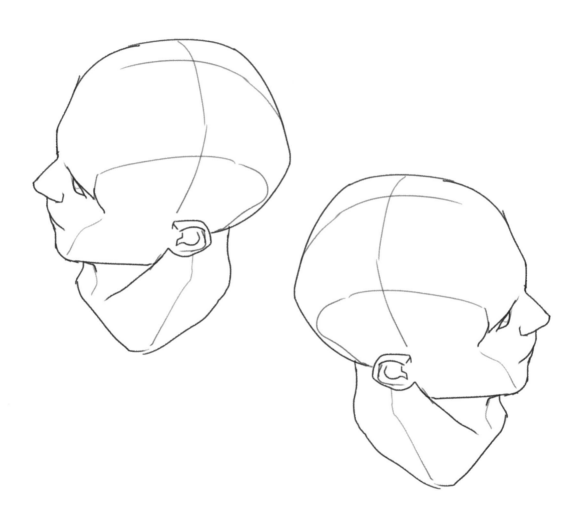

臉部正面低視角
Face front, low angle

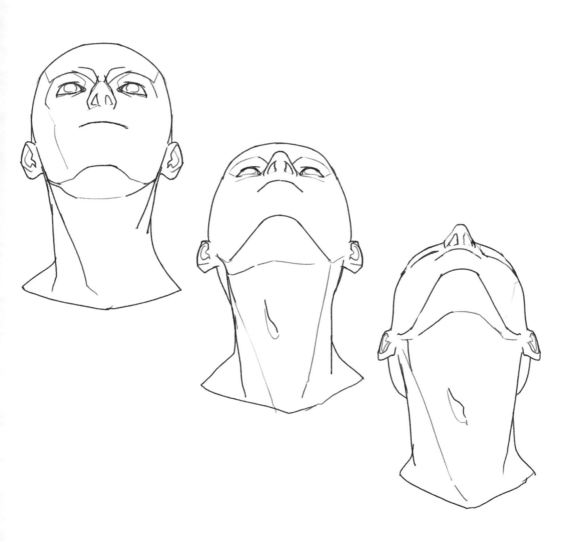

臉部左／右半側面低視角
Face 3/4 view, low angle, left/right

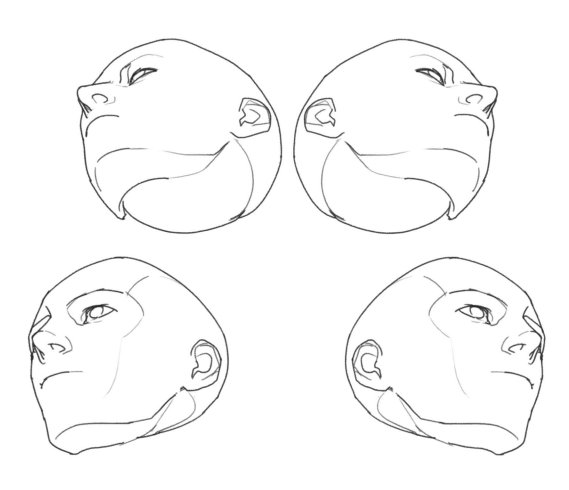

臉部左／右側面低視角

Face side, low angle, left/right

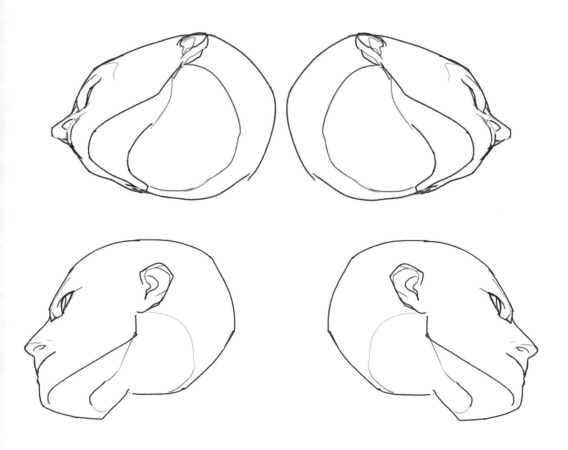

人體正面，左／右半側面

Human body front, three quarter 3/4 view, left/right

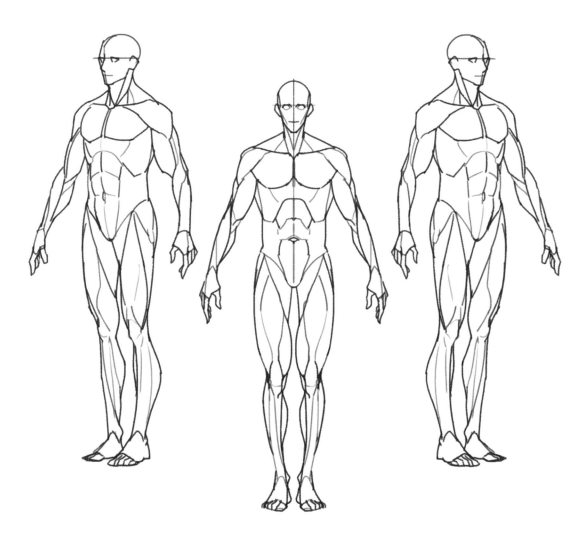

人體左／右側面

Human body side, left/right

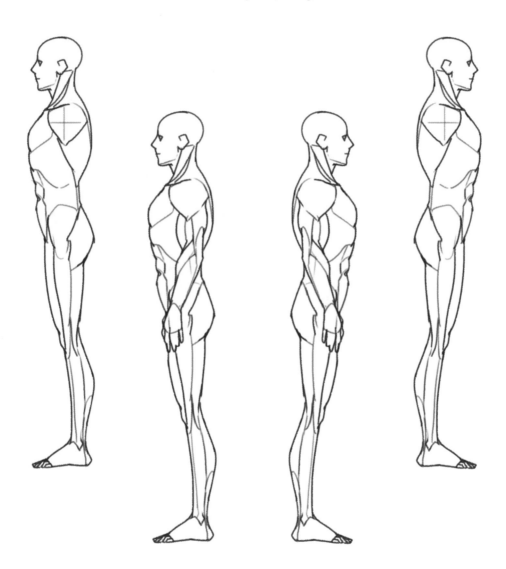

人體背面，左／右半側面
Human body back, 3/4 view, left/right

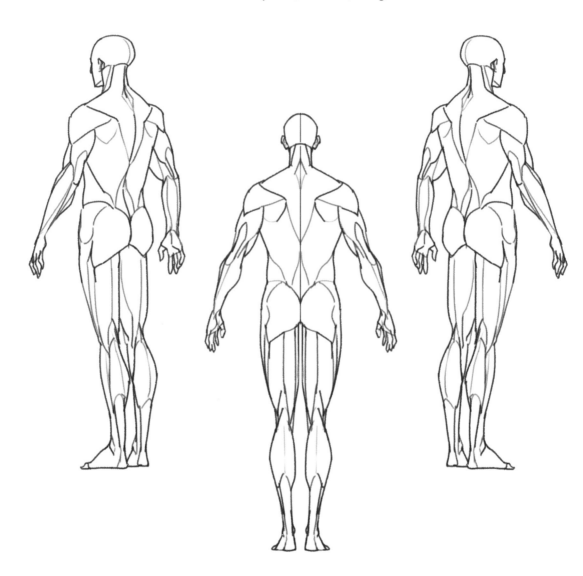

人體正面，左／右半側面高視角

Human body front, 3/4 view, high angle, left/right

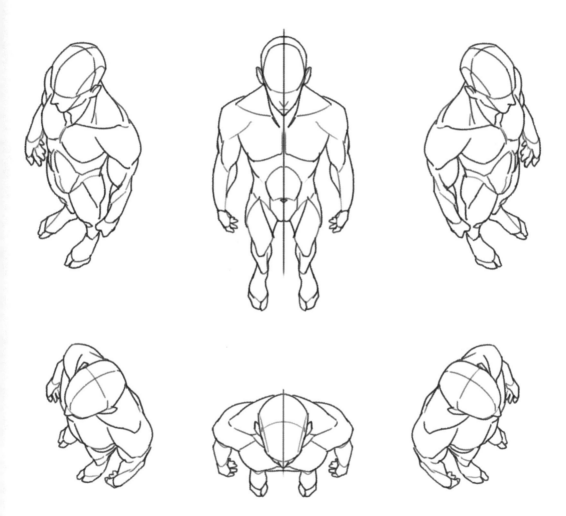

人體左／右側面高視角
Human body side, high angle, left/right

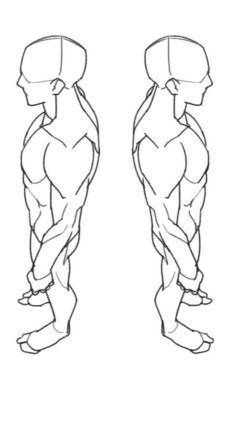

人體背面，左／右半側面高視角

Human body back, 3/4 view, high angle, left/right

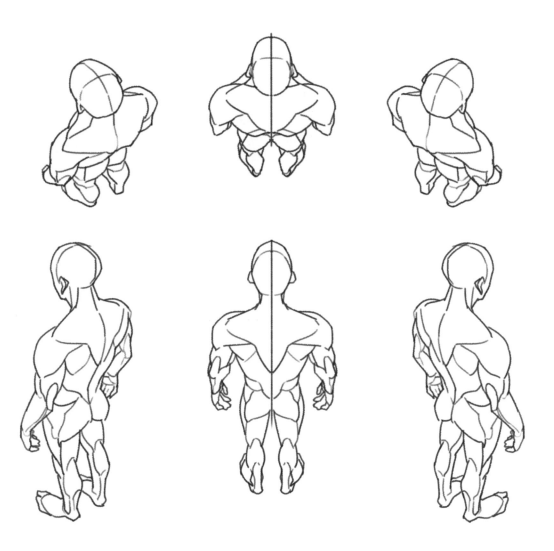

人體正面，左／右半側面低視角
Human body front, 3/4 view, low angle, left/right

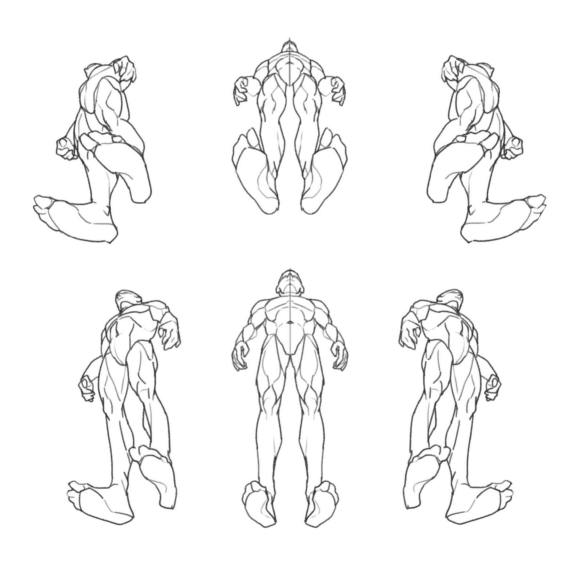

人體左／右側面低視角

Human body side, low angle, left/right

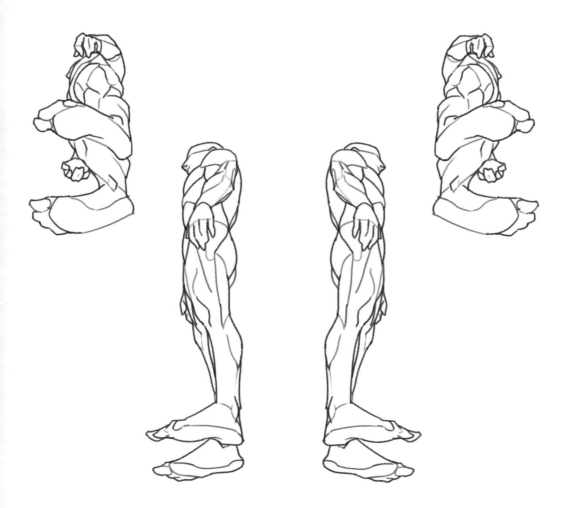

人體背面，左／右半側面低視角
Human body back, 3/4 view, low angle, left/right

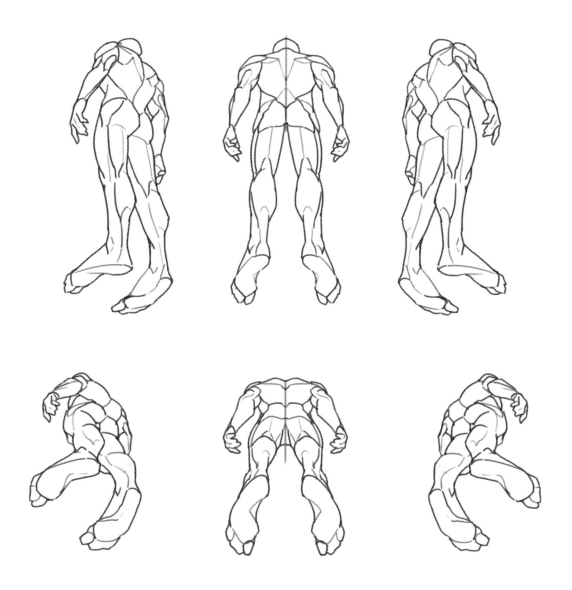

# 韓國繪師的
# 角色繪製重點攻略──vol.2

出　　　版／楓書坊文化出版社
地　　　址／新北市板橋區信義路163巷3號10樓
郵 政 劃 撥／19907596　楓書坊文化出版社
網　　　址／www.maplebook.com.tw
電　　　話／02-2957-6096
傳　　　真／02-2957-6435
作　　　者／崔元喜
翻　　　譯／林季妤
責 任 編 輯／王綺
內 文 排 版／楊亞容
港 澳 經 銷／泛華發行代理有限公司
定　　　價／320元
出 版 日 期／2022年9月

國家圖書館出版品預行編目資料

韓國繪師的角色繪製重點攻略 / 崔元喜作；
林季妤翻譯. -- 初版. -- 新北市：楓書坊文化
出版社, 2022.09　　面；　公分

ISBN 978-986-377-799-1（第2冊：平裝）

1. 人體畫　2. 繪畫技法

947.2　　　　　　　　　　　111010533